Derrida Reframed

WITHDRAWN

Contemporary Thinkers Reframed Series

Deleuze Reframed ISBN: 978 1 84511 547 0
Damian Sutton & David Martin-Jones

Derrida Reframed ISBN: 978 1 84511 546 3
K. Malcolm Richards

Lacan Reframed ISBN: 978 1 84511 548 7
Steven Z. Levine

Baudrillard Reframed ISBN: 978 1 84511 678 1
Kim Toffoletti

Heidegger Reframed ISBN: 978 1 84511 679 8
Barbara Bolt

Kristeva Reframed ISBN: 978 1 84511 660 6
Estelle Barrett

Lyotard Reframed ISBN: 978 1 84511 680 4
Graham Ralph-Jones

Derrida Reframed

A Guide for the Arts Student

K. Malcolm Richards

I.B. TAURIS

Published in 2008 by I.B.Tauris & Co. Ltd
6 Salem Road, London W2 4BU
175 Fifth Avenue, New York NY 10010
www.ibtauris.com

In the United States and Canada distributed by Palgrave
Macmillan, a division of St. Martin's Press, 175 Fifth Avenue,
New York NY 10010

ISBN: 978 1 84511 546 3

A full CIP record for this book is available from the British
Library
A full CIP record for this book is available from the Library of
Congress
Library of Congress catalog card: available

Typeset in Egyptienne F by Dexter Haven Associates Ltd, London
Page design by Chris Bromley
Printed and bound in the UK by T.J. International, Padstow, Cornwall.

Contents

List of illustrations

Introduction

The texts of Jacques Derrida (1930–2004) cross many different fields of creative and intellectual inquiry. A dominant figure internationally, few thinkers of the late twentieth century factor so prominently in any consideration of the larger debates delineating contemporary critical theory. The term 'deconstruction', a word Derrida first used some forty years ago, has by now become so pervasive that not only is it a word heard regularly in regard to academic fields, but also it has become a regular feature of studio discourse. The term is even bandied about on a regular basis within popular culture, on television shows, the Internet or cinema. Whether in the artist's studio or the corporate mass media, the prevalence of 'deconstruction' as a word in contemporary culture makes a familiarity with the texts of Derrida that much more vital to students wishing to understand contemporary cultural trends, as well as gain insight into some of the enduring structures ordering the visual arts.

In addition, few contemporary thinkers offer reflections on a comparable scope of topics. While his earliest texts address primarily the fields of philosophy and literary criticism, his later writings experiment more and more with literary form. During the last two decades of his career, as his visibility as an intellectual grew, he used his position as a public figure to address a wide range of topical concerns, including the Mumia Abu-Jamal case, AIDS, drugs, nuclear proliferation, apartheid, terrorism, homelessness, and the *sans papiers* or undocumented immigrants in France. In addressing contemporary issues, Derrida allows his

thought to become more accessible to a general public through the mass media, as can be seen most frequently with regard to his numerous interviews. On such occasions, Derrida uses a more common language to offer reflections on current issues related to his academic research. His texts and interviews, later in his career, begin to directly address ethics, the role of academic institutions, legal studies, friendship and theology.

In reframing Derrida for this series, I endeavour to focus the reader's attention on the relevance of Derrida's thought to students of the visual arts. The following ten chapters introduce the French philosopher's work by presenting some of his key texts relating to the visual arts. In considering his texts, we will see how we can begin approaching his seemingly complicated work through exemplars of contemporary and historical visual culture. As with other volumes in this series, the premise of the text is to present the complicated work of thinker 'X' and offer some way of calculating the relevance of his or her thought to individuals interested in the visual arts, but unfamiliar with critical theory. While no volume in this series can adequately address all the reasons why the subject of its text is important to an understanding of contemporary visual culture, it is the hope that the present text can in some small way initiate the reader's encounter with the work of Jacques Derrida.

Rebel with too many causes: JD's early years

Jacques Derrida was born on 15 July 1930, the day after Bastille Day, in the French colony of Algeria, in the small town of El-Biar (near Algiers). Born to the descendants of Sephardic Jews who, in escaping religious persecution, emigrated from Spain and Portugal to North Africa, Jacques was the second son to survive infancy. A sister was born four years later.

The three siblings grew up during a turbulent time in Algeria. As Jews within a French colony, their legal status was impacted by external tensions within Europe during the rise of anti-Semitism.

The Vichy regime in France, a puppet government supporting the Nazis, took away the status of French citizenship from Algerian Jews. While Derrida's town avoided occupation during World War II, his life was affected by the quotas imposed by the Vichy regime on the numbers of Jews allowed within a school. The Jewish students allowed to attend often faced institutionally sanctioned anti-Semitism. For instance, after reading the name of a Jewish student, a headmaster would declare, 'French culture is not made for little Jews.' In the case of young 'Jackie' (as his family called him), he first was expelled from his state-supported school, but then avoided the clandestine schools being led by Jewish teachers locally.

As a teenager, Derrida continued to show little interest in academic pursuits. His chief passion was football and his aspiration was to become a professional player. At the same time, while not displaying any great academic interest, Jackie began showing literary and philosophical interests. In particular, the work of the French phenomenologist Henri Bergson (1859–1941), whose ideas regarding how human consciousness apprehends the world relate intimately to the developments of cubism in the early twentieth century, and the work of the French existentialist Jean-Paul Sartre (1905–80) inspired Derrida to pursue philosophy more seriously. Sartre was the leading intellectual figure in France during the post-World War II era. His thought spread internationally, appearing first in English after 1946, just in time to quench the angst-ridden thirst of a post-Hiroshima, post-Holocaust, early Cold War epoch. After failing his *baccalauréat* exam the first time, Derrida passed this French educational rite of passage and entered the Lycée Bugeaud in Algiers.

Subverting the system from within: JD at École Normale Supérieure

Derrida first applied for entrance to the prestigious École Normale Supérieure in 1949, but failed his entrance exams. During his

second attempt he experienced a nervous breakdown, and needed to return home to El-Biar to recuperate. He was finally admitted to the École in 1952. The École Normale Supérieure was the setting for one of the most vital meeting of minds to mark the second half of the twentieth century. Early in his career at the École Normale, Derrida befriended the structuralist Marxist Louis Althusser (1918–90), whose work was just beginning to gain some renown in France. Althusser's rereading of Karl Marx during the 1960s and 1970s in some ways mirrored the rereading of Sigmund Freud being undertaken at this time by the French psychoanalyst Jacques Lacan (1901–81), whose lectures Derrida also attended. Althusser's career ended in tragedy, as he shot his wife and spent several years in an asylum. Derrida also attended the lectures of the structuralist historian Michel Foucault (1926–84). Foucault's thought has also had a great impact on the visual arts, achieved through his essays on Diego Velázquez's *Las meninas* (1656), the paintings of René Magritte and Jeremy Bentham's idea of the panopticon. Foucault's work explores the way the human gaze is structured by discourse or language. Each field within the modern world, for Foucault, constructs its area of expertise through a specialised language. The intellectual climate at the École Normale gave Derrida exposure to the key thinkers associated with the ascendance of structuralism. Structuralism is a way of analysing a field of inquiry by understanding the values within a particular system as being structured around oppositions. Deconstruction destabilises the oppositions ordering structuralist analysis, as will be discussed later.

The post-World War II era witnessed a period of great political, intellectual and creative transformation in France. On the political front, the Algerian war proved to be a highly unpopular conflict that nearly toppled the conservative government of World War II hero Charles de Gaulle. Opposition to the war mobilised countless intellectuals, both young and old, to action, including the reclusive writer Maurice Blanchot (1907–2003). Blanchot, whose work will

influence Derrida, emerged out of a long period of silence in response to the Algerian war.

A rebellious element also emerged in the visual arts. The Situationist International emerged as a powerful creative force impacting continental European culture. Rooted in the writings and visual work of Guy Debord (1931–94), the Situationist International offered an approach to the world involving spontaneous actions breaking the rules ordering a particular situation. The Situationists inspired rule breaking by students in France, and elsewhere in continental Europe, as student activism was just beginning to appear on the horizons of America's shore. The theatrical slogans associated with Debord's highly influential book and (later) film *La société du spectacle* (1967, *The Society of the Spectacle*) appeared as graffiti on buildings during the tumultuous events of May 1968. In Derrida's method of deconstruction, one can see a parallel to the tactics of the Situationists. Derrida, in approaching each text as a singular event, takes a look at the forces already at work within the text or institution he is analysing.

The early films of French New Wave directors Eric Rohmer (1920–), François Truffaut (1932–84) and Jean-Luc Godard (1930–) also emerged out of this environment. The work of these filmmakers involved breaking the traditional rules of filmmaking. Unscripted scenes, amateur actors and hand-held camera work allowed these directors to offer powerful moments of reflection on the way we gaze at images. Derrida's work shares this self-critical gaze, questioning the very assumptions we bring with our gaze. The relation between Derrida's thought and developments in French cinema is discussed further in the last chapter of this book.

At the École Normale, Derrida began studying the work of the German phenomenologist Edmund Husserl (1859–1938), whose early work became the subject for his dissertation. In 1956 Derrida passed the *agrégation*, an examination that determines whether an individual is eligible for a higher teaching post. Passing the *agrégation* is highly coveted in France, as it guarantees a

successful candidate a state job for life. In 1957 he travelled to the United States for the first time, receiving a grant to study unpublished texts by Husserl in the archives at Harvard University. Derrida's interest in literature reappeared at this time with his reading of the work of James Joyce (1882–1941). The late 1950s was marked by renewed turbulence in Algeria. Jackie returned to carry out his required military service in the town of Koléa. He served in civilian clothing as an educator teaching French and English to French Algerian children. With the victory of the Algerians securing independence, Derrida's family relocated to France. If his status as a non-citizen was in question at times by the French government, his perceived status as both Jewish and European made staying in a newly independent Muslim nation untenable. The immigration of Derrida's family from Algeria was mirrored by many other Jewish and Muslim families, contributing to the social tensions marking the revolutionary times of the 1960s. The tensions between the Muslim world and France continue to have repercussions, as most recently and tragically seen in the riots of 2005.

The emergence of deconstruction

These formative experiences may be seen as marking Derrida's work in several ways. First, his interest in the idea of difference may be related to his experience of being perceived differently depending on who is doing the gazing. Perceived as a Jew in Algeria by a French gaze, Derrida is viewed as either being European or not being European depending on the ideological gaze of authority involved. Living as a Jew in an Islamic country, Derrida is viewed as being a European outsider and a religious outsider. The fluctuating nature of his identity depends on who is doing the looking, revealing a world where identity is multiple and eccentric to the individual. Others come to impact who I am. Through the gaze of the Other, I am born in the visual, given an identity beyond my mortal body.

A critical event in the ascent of Derrida's identity as an international intellectual occurred at the Johns Hopkins University in Baltimore during 1966. The occasion was a conference on structuralism. At this time, structuralism was at its apogee as a critical force. The work of the structural anthropologist Claude Lévi-Strauss (1908–) had attempted to demonstrate how structuralism allows us to study 'primitive' societies, finding larger structuring oppositions to the civilisations we inhabit. Derrida, however, boldly proclaimed structuralism's purported revolutionary approach to the world to be simply another repetition of the same totalising tendency marking the traditional discourse of Western thought. Derrida's distrust of systems seeking to bring a singular interpretation to a field of theoretical inquiry may be related to his experience of colonialism. Colonialism was a system that benefited one party at the expense of another party, and Western thought echoes this bias by trying to proclaim one way of interpreting the world or work of art to be the sole way. Derrida, in trying to counter this tendency, offers an overture toward a new complexity, to understanding how our interpretations of politics, religion, or works of art are delimited by the structures allowing us to represent our ideas.

In 1967 Derrida published three books, and the rest is, so to speak, intellectual history. Familiarising students of the visual arts with the most relevant chapters in that history is the project of the following pages. In reframing Derrida, I have chosen to present important texts relating to issues of concern to students of the visual arts. The reader not only will be introduced to important texts on the visual arts (including *La Vérité en peinture*, Paris: Flammarion, 1978 – *The Truth in Painting*, trans. Geoff Bennington and Ian McLeod, Chicago: University of Chicago Press, 1987; *Mémoires d'aveugle: L'autoportrait et autres ruines*, Paris: Musée du Louvre, 1990 – *Memoirs of the Blind: The self-portrait and other ruins*, trans. Pascale-Anne Brault and Michael Naas, Chicago: University of Chicago Press, 1993; and *Lecture de droit de regards*,

Paris: Minuit, 1985 – *Right of Inspection*, trans. David Wills, New York: Monacelli Press, 1998), but also to some of the key ideas behind Derrida's theory and practice of deconstruction. Special attention will be given to important points of resonance between Derrida's thought and the concerns of visual culture. In doing so, the reader will be offered many points of entry into the fascinating work of the father of deconstruction.

Despite his prolific record of publishing, Derrida was frequently vilified in the French media and the world of academia. As a critic of institutions, his work has been the target of countless attempts to marginalise it from both the left and the right. One famous case in the English-speaking world involved the outrage surrounding Derrida's nomination in 1992 for an honorary doctorate from Cambridge, leading to an unprecedented (and futile) attempt by the academic rearguard to prevent the hallowed British institution from conferring the degree. In France, he did not defend his *Thèse d'État* (dissertation) until 1980. By this time he had revolutionised the fields of philosophy and literary studies, leading to countless opportunities to lecture abroad and avoid the obstacles to his advancement in France. In the 1980s Derrida continued addressing issues related to visual culture, as well as initiating a series of texts on the law. These texts examining the law reflected the emergence of deconstructive legal studies as a field. They also reveal a turn toward questions of ethics that Derrida would pursue up to his death from pancreatic cancer in 2004. These rigorous readings of fundamental philosophical texts brush up against questions concerning the relation between private and public, the law and the institutions that enforce the law, politics in the age of globalisation, questions of identity in a global world and friendship. These themes, at the same time, can be tied to his experimental work of the 1970s, while also offering a reflection on his earliest work.

From the outset, it must be noted that what follows is merely an introduction to one of the most complex thinkers of the late

twentieth century. In reducing his thought to some easier-to-digest sound bites, however, I hope that these bare morsels may offer some sustenance upon the various trails of text this book will lead the reader in introducing the work of Derrida. In reframing Derrida, no single frame can adequately picture his relevance to the visual arts. Nevertheless, each chapter tries to provide a possible attempt to reframe Derrida for visual artists.

Chapter 1

Deconstruction and *Of Grammatology*: What is in a name?

Each book by Derrida published in 1967 (*L'écriture et la différence*, Paris: Seuil, 1967– *Writing and Difference*, trans. Alan Bass, Chicago: University of Chicago Press, 1978; *La Voix et le phénomène*, Paris: Presses Universitaires de France, 1967– *Speech and Phenomena*, trans. David B. Allison, Evanston, IL: Northwestern University Press, 1973; and *De la grammatologie*, Paris: Minuit, 1967– *Of Grammatology*, trans. Gayatri Chakravorty Spivak, Baltimore: Johns Hopkins University Press, 1974) articulates an aspect of Derrida's project of deconstruction. *Writing and Difference* collects essays by Derrida published between 1963 and 1966. Most of these texts appeared in issues of the experimental French literary journals *Tel Quel* and *Critique*. A lengthy essay on Husserl, *Speech and Phenomena* represents Derrida's second major publication on the subject of his dissertation. The third work, *Of Grammatology*, is a lengthy study concerning linguistics.

In an interview (included in the collection *Positions*, Paris: Minuit, 1972– *Positions,* trans. Alan Bass, Chicago: University of Chicago Press, 1981), Derrida discusses his appropriation of the then seldom used French word *déconstruir* (in English, 'to deconstruct') in his early texts. He explains his choice of the term *déconstruir* in relation to his effort to translate a passage from the work of the German philosopher Martin Heidegger (1889–1976), whose work was of great interest to Derrida. Heidegger was both a student of Husserl and also one of the key influences on French

intellectual thought during the post-World War II era. Much of Jean-Paul Sartre's own brand of existentialism owes its intellectual force to making accessible aspects of Heidegger's analysis of *Dasein* (literally, 'there-being'; *Dasein* is a term Heidegger uses to differentiate his notion of 'being' from the traditional notion of Being within Western philosophy).

Specifically, Derrida was trying to translate Heidegger's term *Destruktion* ('de-structuring') from the German to the French. For Derrida, Heidegger's notion of *Destruktion* suggested not simply a negative act of destruction, but also a positive act, such as a clearing away of something no longer useful. Derrida's decision to use the disused French word *déconstruir* allowed for layered associations not only to Heidegger's term, but also to his own contentious relation with structuralism. The term 'to deconstruct' conjures an image of a structure or object in mid-air, suspended, all its parts visible. 'Deconstruction' can also conjure an image of something in the midst of collapse, not destroyed, but falling apart – a ruin, even. 'To deconstruct' something suggests that the act of taking something apart can be the first step toward understanding something anew.

Beyond the associations of the word, however, what does Derrida himself want to say through the term *déconstruir*? While this question could occupy several volumes, here I want to suggest that *déconstruir* is just one term among many that stands in for the underlying principles organising Derrida's approach to the texts he analyses. *Of Grammatology* is an excellent place to see these procedures in action. Along with *Speech and Phenomena* and *Writing and Difference*, *Of Grammatology* formulates a great deal of Derrida's theory as it relates to the traditions of philosophy and literature that he had been studying at this time.

At one level, these early texts offer an analysis of the relation between speech and writing. Derrida tries to show, in his presentation of this relation, how in the Western tradition there has been a consistent denigration of writing in comparison to speech.

Speech is seen as being supreme because one is hearing someone speak to you live. ('Is it live or is it Memorex?' 'Live' is presumed to be the best.) Many positive terms are attributed to speech, forming an important strand within the labyrinthine tradition of Western philosophy going back to the ancient Greeks. Speech suggests presence, transparency, authenticity, uniqueness, while writing gets a bum rap as being a mark of absence, open to forgery, duplication, the need to interpret, to read. Derrida pulls on this strand of thought to unsettle the relation between writing and speech.

Derrida cites countless examples in his early texts to show how the relation between speech and writing deconstructs itself. Sometimes this happens by finding instances where writing is praised in opposition to speech, reversing the relation between these two terms. In isolating these examples, he notes the contradictions and anxieties such moments cause. These exceptions to the rule are marginalised and made to seem trivial or unimportant within the texts he is considering. Derrida takes these exceptions very seriously, however, and manages to show how these trivialised exceptions disrupt the entire system of beliefs ordering the Western tradition, allowing him to destabilise the oppositions he is considering. Derrida points to the materiality of sound as a physical trace indicating a potentially larger system of communication in the case of speech and writing. Both are dependent on a system of language requiring a physical trace, either a sound or mark. The materiality of these marks (even the smallest units, *phonè* for speech and *graphie* for writing)[1] reveal both speech and writing as systems of re-presentation dependent on a structure of mediation. The materiality, for Derrida, of the sign marks any form of communication as a representation. As systems of representation, writing and speech share a structural relation in re-presenting a thought through the mediation of either written marks or spoken sounds. Both speech and writing are forms of re-presentation dependent on a mediating system of language that Derrida terms *écriture*.

Ecriture: **writing expanded**

Ecriture as a term literally translates to 'writing', but in the work of Derrida *écriture* stands for an expanded notion of writing: one perceiving any physical trace, including a brushstroke, as something that can be thought of in terms of linguistics. In approaching linguistics, Derrida's work takes up a tradition in continental Europe that had been galvanised by the Swiss linguist Ferdinand de Saussure (1857–1913). Saussure's work concerned the theory of signs. A sign is comprised of two parts: the signifier and the signified. The signifier is the part we perceive, a sound or letters on a page. The signified is the meaning we associate with the perceived signifier. That is to say, language is made up of a series of marks having an established relation to one another that facilitates communication. The letters I present on this page, though mediated by countless hands, eyes and ears, end up being able to be read, if not fully comprehended, by the reader's ability to recognise the juxtaposition of letters as words and the words as sentences. Individual words operate as signs. We recognise the signifier 'dog' through the conjunction of the letters 'd', 'o' and 'g'. At its most basic level, the signified of 'dog' may be a four-legged animal with a tail. For dog lovers, 'dog' may suggest positive associations. For individuals who don't care for dogs, 'dog' may suggest negative connotations.

At a structural level, however, the signified of 'dog' is dependent both on everything that a 'dog' is and everything that a 'dog' is not. The significance of the signifier 'dog' depends on its opposition to other signifiers. A dog is a dog not only for being a dog, but also for not being a cat. A dog is a dog because of its difference from a cat. Derrida latches onto this idea of how difference orders the relation between signifiers, and this has several important consequences, two of which I mention now. First, it reveals how self-identity, a critical concept to the tradition of Western philosophy that Derrida is critiquing, is not self-identical. Our identities depend not only on how we define ourselves, but also on how our identity is given

to us by others. A Self becomes a Self only in relation to a pre-existent Other, and at least two Others, as we typically require two parents to be conceived, even if the age of cloning and artificial insemination greatly complicates matters.

Second, difference affects the construction of meaning. If a dog is defined by its relation to what is not a dog, then meaning arises only out of differences. These differences help to construct a system of beliefs, such as the belief that speech is better than writing. Moreover, Derrida points to two other key features within Saussure's theory of the sign. First, the relation of the signifier to the signified is arbitrary. What does this mean? There is no necessary connection between a signifier and a signified. A word in one language can mean something else in another language, for example. A *faux ami* is a classic case of this. A *faux ami* or false friend is a word that is spelled exactly the same in both English and French, but the term means something completely different in the two languages. For instance, 'car' refers to a motor vehicle in English, but 'car' means 'for' or 'because' in French. Even within English a term from one side of the Atlantic can mean something completely different on the other side of the Atlantic, revealing the arbitrary quality of the signifier. An artist from Zimbabwe once related his embarrassment in asking an American student for a 'rubber' during a studio class in an American university. A 'rubber' in the United States is a contraceptive, whereas for my British-educated colleague it meant an eraser. The significance of the word 'rubber' depends on its context. It can stand for one idea in one context and for another idea in a different context. Beneath the surface, there is no essential relation between the signifier and what the signifier stands for outside a particular system of representation.

Second, in relation to his reading of Saussure's idea of the sign, Derrida points to how the signified leads us to just more signifiers. Think about it. What do we do when we come across a word we don't know? We go to a dictionary to find out what that

word means. And there we find more words! For Derrida, this never-ending chain of signifiers points to the way that there is no closure to the process of interpreting signs and that the process of interpreting signs produces the signified. But this is a signified that is never total, never complete, and always open to change. We can even see this in dictionaries, as we can easily note that the way words have been spelled has changed over the centuries, as well as how the meaning, or signified, of these words has changed over the course of time. Language and the values we construct through language change over time and location.

Writing with a *différance*

Derrida develops a different take on difference, seeing difference arise not by default to some pure homogeneous origin but, rather, as the very place where we start. In echoing Heidegger's use of terms such as *Destruktion*, Derrida begins to write *différence* differently, as *différance*. In French, *différance* sounds exactly the same as *différence*. By spelling it with an *'a'*, however, he willfully spells it incorrectly in order to activate the unsettling effects of deconstruction as performed by *différance*.

Difference fools the ear. Phonetically sounding correct, it is only later upon reading the text that we fully understand that our ear correctly heard something appearing incorrect in the text. In painting there is a tradition known as *trompe l'oeil*. These paintings are associated particularly with an illusionism that literally 'fools the eye'. *Trompe l'oeil* paintings present us with moments where vision itself loses its power to judge. Seeing no longer is believing. For a moment, our eye may be fooled, pointing to the limits of what grounds visual reality, the eye. Within a culture of virtual reality, frequently it is only after a moment that we realise that what we are looking at is reality, only a reality somewhere else. Even within the premise of real-time technologies, an element of deconstructive difference is at play, as what we

see in our mediated images of the world are screened realities constructed by interests vested in visual culture. If *différance* physically fools the ear by having the eye expose an *'a'* instead of an *'e'*, the transformation is not simply an arbitrary occurrence.

When written with an *'a'*, *différance* alludes to how the French verb *différer* means not only 'to differ', but also 'to defer' or postpone, suggesting the idea of a deferred payment, a payment to be made later. The idea of delay is of particular importance, because it suggests a temporal experience of waiting for something anticipated. In financial terms, it is a payment. In spiritual terms, it can take on various forms whether one is Buddhist, Jewish, Hindi, Muslim or Christian. And, of course, within each system of belief there are multiple and conflicting visions.

In relation to *différance* in its manifestations in Derrida's early work, the idea of delay can be thought of in the way the meaning of a work of art accrues only with time. When we examine works of art or popular culture closely and on more than one occasion, the meaning of the work will be different over time. If delay is one element to *différance*, then difference is the other. Derrida, in thinking through what it means to be different, suggests that difference is a relational construct. These relations of difference imply a spatial distance. Nevertheless, this spatial distance structuring our exterior relations to the world is simultaneously a structure dependent on internal constructs. These internal constructs framing our relation to the world collide with the myriad external structures that come to mediate our visual experience.

In this way, the visual arts seem a perfect place for *vivre la différance*, as the idea of *différance* takes on many different forms. Just as viewers in the Salon of 1865 could be shocked by Edouard Manet's *Olympia* (1863), our own culture creates a sensation with a *différance*. The Saatchi collection stirred controversy differently in exhibitions at the Royal Academy of Arts in London and the Brooklyn Museum of Art in New York. The

focus of controversy in London was Marcus Harvey's *Myra* (1995), a portrait of the infamous child murderer Myra Hindley, while in New York it was Chris Ofili's *The Holy Virgin Mary* (1996). The portrait of Hindley, whose deeds may be known to some Americans through the Smiths' song 'Suffer Little Children', unsettles the viewer because of an added visual difference occurring when the painting is examined up close. The portrait is a composite image of children's handprints, taking up a technique most closely associated with Chuck Close's illusionistic portraits.

What is interesting in the case of Ofili is the role that American politics played in creating the sensation around his painting. As with the culture wars of the 1980s (the controversies around government funding of exhibitions showing the work of artists such as Robert Mapplethorpe and Andres Serrano), politicians courting the religious right, such as then mayor Rudolph Giuliani, expressed opposition to the show, largely taking offence at Ofili's use of elephant dung (a powerful material associated with African spiritual practices). Clearly, Giuliani did not inspect the work with a deconstructive eye, or he did not notice the butterflies surrounding the Virgin that were made by cutting out images from pornographic magazines.

In wanting to see a traditional icon of the Virgin Mary, or in anticipating being offended, or in not looking at the painting at all, or all of the above, Giuliani is disappointed by what he sees as simply offensive. At the same time as this work is simply offensive to politically motivated gazes, the same work raises questions about the relations between the base material world, as embodied in the dung and pornography, and spiritual transformation, as in the form of reborn caterpillars turned butterflies, and the Virgin Mary represented no longer as European but Afro-Arab. In the case of Harvey and Ofili, their works show in the different controversies caused by the 'Sensation' exhibition how difference affects the world we experience, each differently.

Always marked by *différance*, Derrida's thought suggests the ways that the process of constructing meaning neither ends, nor is a singular process in time and place. That is to say, works of art, such as the *Mona Lisa* (1503–5), acquire different meanings at different moments in history. If the portrait in the sixteenth century could be seen as an unfinished commission, one of many by Leonardo da Vinci, in the nineteenth century it can be seen as a sublime work of Romantic mystery by the English aesthetician Walter Pater. Meaning is impacted both by time and place, as well as tradition. Someone in Philadelphia with a background in art history will view the *Mona Lisa* differently from a farmer in rural India, but, more than likely, it will also be the case that an art critic in New York will view a work differently from an art critic in London, though what they discuss may have more in common than what separates critics from two different time periods. Thus, a contemporary art critic in New York will view art differently from a critic from the nineteenth century. The same would apply for philosophers as well. Our views are marked by differences that come to contour who we are as individuals in relation to one another.

The language that art critics, philosophers and farmers use always bears a mark of difference, and that is because the meaning of what is being discussed is constantly changing even when dealing with the same object, such as a painting by da Vinci some 500 years ago. What Derrida notices, however, within the case of philosophy is that some values seem to ground all the structures through which the construction of a discourse take place. In breaking down texts from the Western tradition, Derrida notices several constants arising out of his explorations in language. The very book title *De la grammatologie* (*Of Grammatology*) suggests the trajectory of Derrida's explorations.

The dangers of supplementation

In devoting his study to the phonemes, glyphs and other arcane bits making up the units of language we more commonly wield as

English, French, German, Spanish and the innumerable languages used to express different but similar ideas, Derrida turns to the traces making up language. These bits have a material element, such as a sound or a mark. The mark is a visual sign, and, here, we can see how Derrida's work may be important to the visual arts, because art is about mark making. I discuss the idea of the mark and how it operates as a visual trace in the next chapter.

Derrida, in his exploration of the privileging of speech over writing notices a whole series of other oppositions that play a key role in the Western tradition of philosophy called metaphysics. Metaphysics does not refer here to the type of book you find in the New Age section of a large corporate bookstore. Metaphysics, as Derrida discusses the subject, refers to the philosophical tradition of reflecting upon the world. If physics offers a scientific approach to the physical world, metaphysics allows us to talk about our experience of the physical world. The tradition of metaphysics includes the most important names of the Western philosophical tradition, including Socrates, Plato, Aristotle, Heraclitus, Immanuel Kant, Georg Hegel and many others. In his analysis, Derrida notes a privileging within this tradition of presence over absence, the whole over the fragment, purity over impurity, original over copy, and the serious over the frivolous, to name a few key oppositions.

The type of analysis that Derrida carried out throughout his career involved an exhaustive attentiveness to moments in a text where its constructed system of values was thrown into disarray. Preferably, such moments for Derrida can lead to a good deal of playful linguistic humour. A classic example from *Of Grammatology* concerns Derrida's reading of Jean Jacques Rousseau's *Confessions* (1782). Rousseau was one of the first thinkers to craft a modern notion of Self, offering a critique of the way Western institutions confine the Self. Rousseau makes a call for a return to 'primitive man'. In his consideration of Rousseau's text, Derrida notes how Rousseau discusses his habit of masturbation. Rousseau

confesses that he sometimes feels nearer to his love when he masturbates thinking of her than he does when he is actually making love to her. In working through his moral quandary over his act (within a Catholic country), he concludes that masturbation is a supplement to the 'natural' act of sexual intercourse with a partner he loves. As a supplement, it is seen as a potential danger and should be kept to the margins of our awareness.

While seeing a great mind wrestle with his sexual proclivities may be amusing, as it is not the typical subject matter of philosophical discourse, Derrida sees in Rousseau's *Confessions* a pattern of thought that repeats itself throughout his other philosophical discourses. These discourses of thought repeat the same gesture of privileging values associated with Western metaphysics. And, most interestingly, writing is another dangerous supplement. It comes to supplement speech. Writing can imply distance, as in a letter we receive in the mail from someone in a distant country. Such distance is opposed to the physical proximity and immediacy of speech, even if we can record a speech. Speech is how we should communicate, but writing can be OK if kept to the margins. Yet, as with Rousseau's acts of masturbation, sometimes we can feel closer to someone when we write. In writing one can carefully edit what one has to say to get closer to the exact phrasing one wants. Sometimes, in speaking, one can be nervous and easily get confused. Why, then, is the supplement seen as being 'dangerous'?

Because the supplement makes possible sequels. Or, even worse, prequels. That is to say, the supplement is something added to a whole, transforming our sense of the completeness of the whole. For instance, I can recall seeing *Star Wars* (1977) in the movie theatre. At the time, the film seemed to tell a complete story. Then along came a supplement, the sequel, *The Empire Strikes Back* (1980), and, finally, a conclusion in *Return of the Jedi* (1983). By the mid-1980s, 'Star Wars' began to refer just to the Star Wars trilogy of movies, and one could see how

the three films made an integrated narrative arc, from beginning to end.

Then came a trilogy of prequels, beginning with *The Phantom Menace* (1999), and our sense of the whole Star Wars saga is added to, supplemented, by the new films (*Attack of the Clones*, 2002, and *Revenge of the Sith*, 2005). The series, while momentarily complete, is open to future supplementation, not only by new films, but also by novels, video games, cartoons and other forms of mass mediation that come to alter what we once considered the original work. The possibility of supplementation exists within the construction of any work. Any visual or literary work can be added to, potentially. Not only does this mean that no work is ever complete. There can always be another prequel or sequel, even to the six Star Wars movies. Moreover, a new film could be placed in the middle of the two trilogies. Any series is open to new instalments.[2]

The supplement reveals a lack within the original work. The original work, while telling something of the narrative of *Star Wars*, needs the supplement of the sequel. In part, there are always questions that remain unanswered from the original work, such as: 'What happened to Darth Vader?' The next sequel addresses questions left unanswered from the first sequel, such as: 'What has happened to Han Solo?' The third film offers a conclusion to the trilogy, but it also leaves a question as to what could possibly happen to the characters next, leading to future supplements. *Star Wars*, originally the original and then the original beginning, is subtitled, retroactively, *A New Hope* (suggesting an earlier hope), and the prequel offers a new new beginning, even if there is always the phantom menace of the supplement – an even newer beginning.

Or so the supplement reveals, according to Derrida. He explores the implications of the supplement on philosophy in *Of Grammatology* as well as in the three books he published in 1972 (*La dissemination*, Paris: Seuil, 1972 – *Dissemination*, trans. Barbara Johnson, Chicago: University of Chicago Press, 1982;

Marges de la philosophie, Paris: Minuit, 1972 – *Margins of Philosophy*, trans. Alan Bass, Chicago: University of Chicago Press, 1982; and *Positions*). Through Derrida's exploration, in these texts, of the implications of the supplement, the idea of a pure origin is utterly ruined, at least in terms of Western metaphysics. The origin is never pure, because, according to the logic of the supplement, there can always potentially be a more original origin, an origin before the origin. Moreover, the origin is in need of the supplement in order to achieve its identity as an origin. No origin without supplementation.

The idea of a pure work, likewise, is corrupted. Any work can be supplemented by additions. These additions do not necessarily take the form, in art, of additional brushstrokes being applied to a work, but also can refer to essays on the work, as well as appropriations of the work through visual quotations by other artists or even the 'original' artist herself or himself.[3] Any claim for the work's autonomy becomes susceptible to its potential for supplementation. Any work may be altered later by other hands, transforming the original, even works considered masterpieces. Leonardo da Vinci's *Last Supper* (1495–8) or Rembrandt van Rijn's *The Night Watch* (or *The Company of Captain Frans Banning Cocq*) (1642) have been cut into or altered on more than one occasion, and numerous others works could be cited. No work (or list of works) is ever whole or complete.

If ideas integral to Western tradition, such as the origin, the original, and the work, could be open to the effects of the supplement, then what of the structures housing the other tenets of Western metaphysics? The supplement, while seemingly a marginal concept, reveals the need for supplementation existing in any concept or work. The universality of the supplement means that, potentially, any structural relation is bound to shift as additions are made to the 'original' structure. Moreover, all attempts to fix any structure discussed in Western thought, including the 'original' structure, are bound by time, place and

the vested interests of the one authoring the text or supporting the text's author. Not simply relativism, Derrida's reading of the supplement suggests that all structures are doubly binding relations relating to the relative interests of the individuals fixing the structure's foundations, such as philosophers. Finding the weak spots in the foundations of Western metaphysics is Derrida's own small, parasitical supplement to the tradition.

For the Western tradition, the supplement is dangerous because it disrupts the 'natural' order. Of course, the 'natural' order is not natural from Derrida's point of view, but a construct built up over time. In regard to *Of Grammatology*, the threat posed by masturbation supplanting sexual intercourse and writing supplanting speech is that it throws into chaos the carefully delineated structure of values that Rousseau is preserving. Presence should be privileged over absence. Nevertheless, Rousseau feels closer to his wife at a distance than he does when he is as physically close to her as he can be. It is not a question of whether he should feel this way, but why he should feel that he always has to privilege presence and reject absence. And this has to do with the values underpinning his belief system. Values are structured in positive and negative terms, resulting in rigid structures. These structures are revealed to be rigid in the instances where the consistency of their underlying logic is challenged by something different. Sometimes absence is better than presence. Absence makes the heart grow fonder.

One way to think about the supplement is in relation to vitamins and dietary supplements. In trying to stave off or slow down the effects of decay, some of us take pills that provide nutritional supplements. The idea of the nutritional supplement reveals that our bodies are in need of supplementation. Because of the hectic pace of life, with all its delays and deferrals, people eat poorly and require the supplement of vitamins. Of course, the question concerning dietary supplements is not so much a matter of healthy or unhealthy eating habits but, rather, that even a body

eating healthily requires dietary supplements. The supplement is constructed as a supplement from the start, but the body needs supplementation from birth to death, from the breast to the artificial tube. In the form of the pill, the vitamin supplement forms only one of a plethora of supplements to the never fulfilled body. The mortal body is marked by death (the ultimate deferred payment) and decay from the start, just as the origin is in need of the supplement from the start for Derrida. We construct the origin only after a period of delay, deferral and difference – or *différance*.

Open confessions

Derrida is not so much interested in pointing simply to the exceptions to the rule, but in finding cases that also resist any easy ordering by an either/or logic. That is to say, Derrida is critical of any system that determines things as either 'X' or 'Y'. Instead, he seeks a logic of both 'X' and 'Y'. Rousseau's *Confessions* are such a creature in themselves. As confessions, they fit into a literary tradition that was of great interest to Derrida. An example can be seen in Derrida's essay 'Circumfession' (*Jacques Derrida*, Paris: Seuil, 1991 – *Jacques Derrida*, trans. Geoffrey Bennington, Chicago: University of Chicago Press, 1993), which negotiates the tradition of confessions primarily through returning to Rousseau and focusing on Saint Augustine, the fourth-century monk of Hippo whose *Confessions* (c. 400) was another important text within the tradition that Derrida was engaging. The literary confession is a public work about private thoughts. Often they are texts published posthumously. Of course, confession can have a religious connotation, as well as a legal connotation, and the conjunction of the law with religion is another area that will be of interest late in Derrida's career. For our purposes here, it is important to note that the confession is not quite autobiography and not quite a legal or theological confession. It is a literary genre and, as such, provides a space to construct an identity that is rooted, in part, in an individual's public persona. The more public (and sensational) the

persona, the greater the public interest in the confessions. What are confessed are private thoughts, however. So, in a way, the literary confession is both private and public. The confession is also a type of text that is often seen as less important than a work focusing on an individual's field of expertise. Thus, Rousseau's *Confessions* are secondary to his *Social Contract* (1762). As a marginal literary form, Rousseau's *Confessions* grabbed Derrida's attention as a potential site of deconstructive activity. Deconstruction involves the momentary disruption of the structural values allowing for the smooth construction of a discourse.

The form of the confessional has also been of interest to many contemporary artists. From the paintings of Sarah McEneaney to the infamous tent of Tracy Emin, *Everyone I Have Ever Slept With (1963–1995)* (1995), the use of art as a confessional space has a strong tradition within the recent past. Gillian Wearing takes an interesting approach towards this topic in her series *Confess all on video. Don't worry, you will be in disguise. Intrigued? Call Gillian* (1994). Wearing draws upon a contemporary cultural fascination with confessions. Taking out an ad in one of the free weekly newspapers, Wearing occupies momentarily a space that often has pages devoted to public confessionals. In Philadelphia, this can be seen in the local free weeklies that allow people to take out space and confess their love or hatred publicly, yet anonymously. Wearing, by taking out advertising space in a similar forum, offers individuals the chance to confess something on video. A mask selected from Wearing's collection by the participant protects his or her identity. Participants are told that the work will be included in a gallery opening, making their confession semi-public.

Wearing's work challenges some of the foundational values underpinning discourse on the visual arts. For instance, the Western tradition greatly values the role of the singular author. Wearing's role is as a collaborator. She 'makes' the work by creating the situation. The volunteers perform the piece, telling all

and challenging the traditional notion of the artist as creator. That her work takes up a forum that is popular and uses everyday people also challenges the elitism reigning over the dominant cultural fields. Interestingly, just as Wearing has a piece devoted to confessions, she has a piece devoted to masturbation (*Masturbation*, 1991–2). There could be an entire history to the representation of masturbation in art, from prehistoric art to antiquity, from the Middle Ages to the Renaissance, and into the modern era with Egon Schiele and Marcel Duchamp to the late twentieth century and Vito Acconci's *Seedbed* (1972). In Wearing's contribution to this tradition, she provides two photographs, one of a man and one of a woman, masturbating to a photograph, but what they masturbate to (or, rather, what we the viewer see) is their own self-image placed *en abîme* ('in an abyss' in French), the infinite visual regress occurring when one holds two mirrors up to one another.

In her picture within a picture within a picture within a picture, Wearing offers a reflection on the narcissistic pastimes of all self-lovers, while also revealing a blindness within the structure of self-affection. Her images of self-affectation never allow the viewer to know at what the masturbator is looking. Is it the image of the other masturbator? Like Rousseau, is it an image of someone they desire? Or is it at their own self-image that they longingly gaze? What is the secret of their self-affection? How much affectation is there in affectionate desire? Structured around multiple blind spots, no gaze ever gazes from the position of the other.

While negotiating complexly triangulated relations with others that entwine the Self within a set of untenable structures, the Self (as defined by Western tradition) must first try to bridge a gap within self-identity. In habitually repeating structures of identity, the Self acquires identity, something the repetition of images in Wearing's photographs evoke. If her self-lovers look at replications of themselves masturbating, the tradition of Western philosophy

is often a matter of narcissistically repeating the same values underlying the tradition over and over again, even as the language changes from one generation to another. For Derrida, structuralism, the latest incarnation of this tradition, is no different, and, as a result, must be deconstructed.

Chapter 2

Framing *The Truth in Painting*

Through the word *déconstruir*, Derrida set in motion a cultural force that has touched countless disparate fields of creative endeavour. From fashion to architecture, deconstruction has left its mark on visual culture, and these marks can be traced back, if sometimes circuitously, to Derrida. Yet, in relation to the visual arts, the first book that focuses his attention on the topic is *The Truth in Painting*. Published eleven years after *Of Grammatology*, the book represents Derrida's first lengthy engagement with questions related specifically to the visual arts. If, in *Of Grammatology*, we can see some of the techniques of deconstruction at work, but find the term *écriture* a bit too graphic, we can see in *The Truth in Painting* how Derrida's thought manifests itself in relation to the visual arts.

The book, like many of Derrida's texts, is a fragmented manifestation from the start. Instead of a sustained rumination on the visual arts, *The Truth in Painting* consists of four earlier essays and a supplemental fifth ('Passe-partout') that assure us of four journeys around painting. Two of the essays originated in catalogues for exhibitions by two of Derrida's friends in the visual arts, Valerio Adami (1935–) and Gérard Titus-Carmel (1942–). The other two essays, 'Parergon' and 'Restitutions de la vérité en pointure', will be discussed in greater depth, for they allow an easier entry into the thought of Derrida and the questions he raises concerning the visual arts. In turn we will explore how Derrida's thought helps us approach contemporary visual culture, both as viewers and as artists.

In the margins to the left in both the original French copy and the English translation, the first essay, 'Parergon', announces itself as a set of detached fragments. Taken from earlier lectures, seminars and essays, these detached fragments are sutured together to form a Frankensteinian essay broken up into four parts. The ostensible subject of the essay is Kant's rumination on our attachment to the visual arts, *Critique of Judgment* (1790; also known as *The Third Critique*). Kant was one of the key figures in setting the direction for philosophy within the modern era. His work, in relation to aesthetics, has trickled down over the centuries and to the masses through the slogan 'Art for art's sake'. Kant is critical to the discourse of Western metaphysics that Derrida is taking apart. In part, Derrida tries to re-present Kant's idealism of the subject as already flawed by the very structure of its subjective construction, Kant's thought. Kant, from one of Derrida's perspectives, mistakenly repeats a triumphal narrative offering a Self grounding itself against the chaos of the world through his (Kant's subject is engendered – something Derrida will question) use of reason. In *The Third Critique*, aesthetic experience is offered as a universal experience demonstrating that different individuals share common capacities. Derrida's 'Parergon' is another salvo in Derrida's critique of such triumphal idealism.

But what is a *parergon*? To think through the significance of a *parergon*, we can turn to a similar word appearing both in Derrida's texts and throughout visual culture: a parasite. A parasite is an organism that latches on to another organism, feeding off the host organism. Sometimes, such a relationship can be mutually beneficial, as in the symbiotic relationship between rhinos and oxpeckers. Oxpeckers feed off the parasitical biting flies attempting to penetrate the rhino's thick skin. Parasites, in some cases, may be lethal, as in malaria, flatworms and fungi. A parasite, in any case, corrupts the ideal of the permanent independent body. The human body is always permeable and can become host to parasites, as well as have parasitical effects, as in

the current relation between humans, their technologies and the environment. The parasite fits into a logic of 'both/and', instead of 'either/or', thus fitting into a logic of deconstruction. The parasite is both an independent organism and an organism dependent upon another organism. In its mediated form within popular visual culture, parasites populate the televisual, cinematic field in ever more and new visual forms. From the series *Buffy the Vampire Slayer* (1997–2003) to the video game *BloodRayne* (2002), the vampire presents the classic parasite. A dead person living off the blood of the living, the vampire provides another figuration for deconstruction that obtains its sustenance from the pages of Derrida.

The parasite also alludes to the paranormal, a fascination with which was shown in recent contemporary visual culture by the series *The X-Files* (1993–2002), about cases marginalised within the FBI. The paranormal explores something beyond the normal. Often in relation to these paranormal experiences, a transitory visual phenomenon is witnessed. The continued fascination in American popular culture with the paranormal can be linked to current series such as *Ghost Hunters* (2004–) and *Most Haunted* (2002–). Even the conspiratorial plotlines of *The X-Files* (or other conspiracy-driven television series such as *Spooks* (*MI-5* in North America) (2002–), or *Lost* (2004–), involve an idea of something paranormal or beyond the normal happening within the daily frameworks structuring our lives.

Through the examples of the parasite and the paranormal, we may be able to deduce that the *parergon* is something related to an *ergon*, but not part of what we consider the *ergon*. If the paranormal is not part of normal experience and the parasite is a foreign organism, then the *parergon* is probably not part of the *ergon*. But what is an *ergon*? *Ergon* is a Greek word used by Kant to signify 'work', as in work of art, work of literature, work of music, etc. But what constitutes a work of my field? According to Derrida's reading of Kant, the work or *ergon* depends upon the

parergon. In a footnote, Kant gives three examples of *parerga*, including clothing on a statue, columns on a building and the frame of a painting. In this minor aside, Derrida finds a word that acts as a deconstructive agent already lurking within Kant's text. Acting like a sleeper agent in the spy genre, the *parergon* becomes an agent for deconstruction already present in Kant's text.

Derrida takes the idea of the *parergon* and runs with it, exposing how the *parergon* is something that undoes the relations ordering Kant's main discourse in the *Critique of Judgment*. Derrida cites paintings, such as Lucas Cranach's *Lucretia* (1532), that represent a nude woman wearing a transparent veil, columns on buildings that are statues, such as the caryatids on the *Erectheion* (421–05 BC) at the Acropolis, and other hybrid combinations of frames, clothing and columns. In these examples, Derrida presents hybrids of the neat categories that Kant tried to construct through the idea of the *parergon*. The *parergon*, for Kant, becomes a category for relegating the marginal elements that complicate the categorical definition of a work. The *parergon* is the convenient limit to the *ergon*, even when the *parergon* exists within the work, as with a column supporting a building. Existing in potentially two sites, both within and beyond the *ergon* or work, the *parergon* complicates a relationship Derrida explored earlier in *Of Grammatology*, the relation between inside and outside. Neither inside the work nor outside the work, the *parergon* follows a logic of 'both/and/neither/nor' that complicates the 'either/or' logic of Western metaphysics that Derrida criticises for its reliance on static structures that crumble because of their rigidity.

The permeable frame

The frame becomes a main focal point for the essay 'Parergon'. The idea of the frame is easy for us to visualise as artists. Yet, as with the concept of *écriture* or writing, Derrida expands our everyday understanding of the frame, loosening the four sides to the frame by expanding how we think about what frames are and what they

do. Frames serve as limits or borders. Traditionally, in painting, they separate a work from the wall. Even in works that don't have a physical frame, as with many contemporary paintings, there is still a frame or limit between the work and the wall. In some clever cases, the frame is painted by the artist, as in the case of Georges Seurat in some of his pointillist canvases, such as *The Eiffel Tower* (1889). Seurat exhibited his painting in a café at the foot of the newly opened tower with works by other members of the *fin de siècle* avant-garde, including Paul Gauguin, Paul Cézanne and Vincent Van Gogh. The Eiffel Tower is a frame of structures just as it is a structure framing the social context in which works now valued and viewed beyond imagination were once shown in anonymity. In other cases, the artist paints upon the physical frame. In still others, the physical frame is fragmented. Regardless, the frame still exists even when there isn't a frame. The frame becomes the determining limit of the work.

Or does it? What else frames how we perceive works of art? Derrida's concept of the frame is supple, suggesting through its allusions relations to larger ideas within his thought regarding cultural and academic institutions. For instance, how, as institutions, do museums, galleries and auction houses frame works of art? Museums may frame works of art as cultural treasures, traditionally with a supporting narrative of triumph or an attempt to make amends or restitutions for a historical event, in its memory. Galleries may present works of art as items indicative of what is new and hot or established and true in relation to the art market. Auction houses might provide the spectacle of theatre in the bidding wars that make headlines in the culture pages of newspapers. The media is one of the forces framing the representation of art. If one compares similar news media from Britain, the United States and France, one can see reflected a process of framing that structures the world mass media. How do we, as viewers, also frame works of art? Do we have knowledge of the artist who made the painting that we are admiring within

a museum, and does that matter to us? All these questions surrounding the work of art already show that we are framing the work. No eye is innocent.

The frame, while a *parergon*, also relates to Derrida's discussion of context. The question of context is brought up in Derrida's essay 'Signature Event Context' (in *Margins of Philosophy*), a text that showed him not only to be an astute student of structuralism, but already an exponent of deconstruction. Context is critical in all acts of reading a work. In analysing language, a consideration of where and when something was written provides one layer to a text or work of art's meaning. Other layers may be provided by how a work was made or who made the work of art. Our interpretations of why a work of art was made adds further layers of text relating to trying to understand a work of art or literature. What Derrida adds or notes, concerning context, is that there is no limit to the possible contexts that any statement or work might find itself in. Context is ever expandable, never exhaustive and never finished. Similarly, the way that works of art may be framed, moving beyond not only the literal possibilities (within works of art), may allow us to consider the frame not simply as something related to painting, but simply related to the way we view the world, the way we frame the world. In framing the world, we choose what to include in our constructed image and what to exclude. We can, in this way, view framing as a subjective process.

At the same time, however, the subject herself or himself is also already framed. Institutions frame us. Experience frames us. Negotiating and navigating the spaces between the external structures framing us and the internal structures framing our narrative of the world, we have all been framed from the start. Derrida makes the working of the frame seem omnipresent, constantly shifting from one moment to another in holding together the subject. Identity, as a result, is founded on a structure that is tenuous at best.

In relation to Kant's use of the term *parergon*, Derrida notes that the tradition of Western metaphysics has been able to discuss only what is inside the frame or what is outside the frame. Never is the working of the frame discussed. In terms of aesthetics, formalism discusses forms within the frame. Formalism is a discourse originating beyond the frame of painting that comes to interpret the meaning of what is represented within the frame. While grounding itself in what the eye perceives, no consideration is given to how the eye is already formed by a vast array of internal and external structures. Formalism as a modern aesthetic discourse can trace one of its multiple origins back to Kant. In determining a work of art, the frame often bears the weight of giving the work its identity as a work of art. Formalism sees significance solely in the visual forms. In early modernism, these forms may simply be there to create pleasure in the viewer, as in Henri Matisse's comparison of a work of art to a piece of furniture, or, as in the discourse of Clement Greenberg, the forms may simply be there to affirm the identity of the medium. If what happens in Las Vegas stays in Las Vegas, as a public ad campaign for the city proclaims, in Greenbergian modernism, what happens in the frame stays in the frame. What happens in literature happens in language. What happens in painting happens in paint alone. What happens in sculpture happens in the materials. Greenberg, through Kant, structures a world where peanut butter and chocolate never collide.

On the other hand, there are traditions of analysis that discuss what is outside the frame, such as the social or Marxist brands of art history. They do an excellent job of accounting for what is beyond the frame of the painting and offer information about the culture within which the work in question was produced. The most subtle and challenging accounts of art may, however, move beyond a simple frame of caricature, offering an account that tries to weave together what is inside the frame and what is outside the frame. But, as Derrida notes, there is no account of the frame and

no way to account for the frame. As such, the frame embodies all the properties of the agents populating the texts Derrida explores.

In addition, the *parergon* corrupts the purity of the *ergon*. Corrupting the façade of purity covering the *ergon*, the *parergon* reveals the subjective interests vested in the time-bound structures we more commonly think of as works of art and literature. If purity is one of the key ideals in the tradition of Western metaphysics, Derrida likes to expose an impurity residing at the heart of this ideal of purity. For Derrida, the purity of any representation is marked from the beginning as a mark, something that is open to being read as a unit within a textual or visual representation and open to interpretation. In the case of the *ergon*, its non-self-identity, the inability of the *ergon* to define itself as a whole, is revealed through the *parergon*. There is no *ergon* without the *parergon*. At the origin of the *ergon* there was the work, but framing that work is already the *parergon*. Never pure, the *ergon* reveals a duplicitous origin.

From early on, Derrida's thought has been concerned with the idea that there is no singular origin, but an origin already existing in relation to some Other. Human life, life as we define it, depends on a cellular process of duplication. Derrida explores the idea of originary duplication in *Dissemination*. Here, the originality of the original is shown as being dependent on the copy. No original without the copy. In 'Signature Event Context', there is no signature without the countersignature to authenticate it. In relation to a work of art, authentication depends on the paperwork that helps to support and supplement the authenticity of the work in question.

As in his earlier work, Derrida revels in seeing a great thinker trip over the guardrail delimiting the limit between the essential and the inessential. In these situations, an act of deciding occurs, one that has to pass through moments where such decisions are almost impossible to make. In most cases, we simply impose the frames we already use to determine what is important from what

is unimportant in 'our world'. These frames do not surround works of art but, rather, surround us. They are the frameworks to the structures within which our daily lives take place. By not noticing them, we become comfortable within them. Only in rare moments do these frames get shaken. Derrida's thought provides a way of shaking these structures, making what is most familiar unfamiliar. In the case of the frame, Derrida exposes something that does not reside comfortably within the rigid structures of Kant's thought, and through the *parergon* points to other possible deconstructive agents.

Place label here

Labels are one such *parergonal* agent. Outside the work and the frame of the work, they often give a viewer information concerning the work. They help to identify who the artist is, what the title of the work is and what the medium of the work is, as well as often the dimensions, who the work belongs to and when the work was made. While not internal to the work, information gleaned from labels often frame part of our experience of the work. We move between the label and the work, and, in this movement, we slowly negate the mythical purity of the work. Ironically, the importance of labels in framing a viewer's experience happens even in the absence of labels. Moving both inside and outside the work, we can see the slippery nature of the *parergon*, its ability to reside in a para-site (almost a site).

Near Philadelphia, the Barnes Foundation provides an opportunity to experience art without traditional labels. Of course, we as viewers already frame the way we approach art. When going to the Barnes, a viewer knowledgeable in early modernism will recognise many of the great masters. Even in the absence of any knowledge by the viewer or any labels or guides to guide her or his eyes, not only are the viewers framed, but also the works of art themselves. Even before viewers enter the building the works of art are being framed by a discourse of pure aesthetic contemplation.

Aesthetic contemplation is never pure. The texts devoted to aesthetic contemplation bear witness to the impurity of aesthetic pleasure. If the Barnes philosophy embodies an ideal of pure aesthetic contemplation, the works themselves are already being framed by that philosophy. For Derrida, this is precisely the problem with not only aesthetics, but also the attempt of philosophy to have the ultimate say on all the fields it claims to have knowledge concerning. Philosophy is already framing art, an object that philosophy purports to be free, while in the same gesture delimiting what frames a work of art. Indeed, freedom isn't free.

If the Barnes Foundation offers one attempt to frame works of art, we can also see several contemporary artists who examine the way museums frame works. In many cases, such a critique happens through a *parergonal* space. What is a *parergonal* space? It is a space that resists any simple ordering by the opposition of inside to outside. As has been suggested, the opposition of inside and outside was critical to Derrida's exploration of the relation between philosophy and the literary arts. In extending his analysis to the visual arts, the *parergon* challenges the relation between inside and outside, occupying a space neither quite outside, nor quite inside the work or *ergon*. In resisting a simple logic of either being outside the work or inside the work, the *parergon* activates the destabilising tactics of deconstruction.

Tripping the limits between what is inside a structure and what is outside a structure, Derrida sounds an alarm for Western metaphysics. The frame provides merely one such phenomenon creating these effects. Fortunately, there are countless visual examples that allow us to perceive questions surrounding the frame and how the frame relates to the work of art. From Magritte's *The Human Condition* (1935) to Michelangelo Pistolletto's fragmented mirrors from the late 1960s and early 1970s, the idea of the frame has been explored as part of the tradition of modern art. Even earlier, one can see artists posing

questions related to Derrida's analysis of the frame, whether it be a self-portrait by Nicolas Poussin or the Hellenistic relief sculptures of the Altar of Zeus from Pergamon (c. 175 BC).

Labels often bear the titles to a work of art, though sometimes titles appear within the work. Marcel Duchamp's *Nu descendant un escalier, no 2* (*Nude Descending a Staircase, No. 2*) (1912) provides one instance of a title existing inside a work of art. Titles can also be cited or appropriated to forge a relation between two artists. The title of Marcel Duchamp's painting of 1912 is referenced by the German painter Gerhard Richter in his own *Nude on a Staircase* (1966). Far from being marginal, a title often provides for the viewer one of the points of passage into the work.

Again, there could be a tradition structured around the title and its relation to a question of what is inside the frame and what resides outside the frame. Titles become even more informative in the case of prehistoric works that are given a title, as the transformation of the *Venus of Willendorf* to *Woman of Willendorf* can testify. Of course, the object itself may never have had a title and may never have been considered aesthetically except through the structures of aesthetics momentarily framing the object in survey texts.

Some contemporary artists have used museum labelling to challenge cultural labelling in the form of stereotypes. Fred Wilson, for instance, in his piece *Mining the Museum* (1992), institutes an angle of deconstructive inquiry in the way institutions are implicated in constructing historical identity. Working with the archives of the Maryland Historical Society, Wilson discovered many surprising items from the age of slavery. Whipping posts, shackles, and other objects associated with the institutionalised abuse of African-Americans were housed with other cultural artefacts of the colonial age. The continuation of slavery in the United States during the nineteenth century, after most European nations had attempted abolition, led to a period of extraordinarily inhumane treatment by one group of humans in power (the

colonial Europeans) over another group of humans (the African slaves) who were part of the basis for this power.

Wilson's shock was not so much in the existence of the objects of torture, because there is ample sobering documentation concerning the abuse of slaves in America during the colonial period and the nineteenth century. The shock was that these physical objects were being preserved, but being preserved to be hidden. That is to say, by keeping these objects, the Maryland Historical Society devotes resources of space to preserve something documenting devices used in the torture of slaves in Maryland's history. These objects were not being exhibited, however. In selecting these objects for his exhibition, Wilson included them among other objects from the same time period, mirroring their storage in the institution's archive. In taking this approach, he constructs a synchronic frame to order the objects. Within a synchronic group of objects (all taken from the same time period), one constructs an image of the past at a particular time. The objects in Wilson's groupings, however, are not just ordered synchronically by period, but also by material.

In structuring his work as the physical result of a set of conceptual decisions, Wilson screens the works to a manageable size for a normal exhibition, functioning as a thoughtful curator. Thus, a room devoted to carpentry includes chairs, chests and a whipping post. In a room devoted to works in metal, one sees refined cutlery and shackles within the same space. In mining and maiming the objective structures ordering traditional museum taxonomy, Wilson 'mines' the museum, making it his. Little else is done to frame Wilson's intervention, but visitors were offered a questionnaire asking for their thoughts and response to the show.

Through the questionnaire, Wilson initiates a diachronic study, opening up a space to discuss issues concerning race both today and within the age of slavery. Wilson's intervention also opens up a space to question and challenge the role of institutions in ordering objects of the past. The privileging of aesthetic experience

instituted through the work of Kant and his interpreters led to the ideal of art for art's sake. The ideal of pure aesthetic contemplation is offered as a means of escaping the drudgery of the everyday world. Cultural institutions are founded and flounder upon such ideals.

For Wilson, it seems that the role of institutions in constructing our image of the past impacts in some way our image of the present. In framing what is included and excluded for an exhibition, numerous decisions must be made. In the space of the archive, however, reside objects that have the potential to deconstruct the values framing an institution, as Wilson shows repeatedly in his role as a curator. Wilson's artistic interventions within institutions such as museums lead to a questioning of his own role as a producer of art. In not producing an object to be consumed, he is taking up a tradition of art that criticises the institutionalisation of objects, a tradition including artists such as Duchamp, Marcel Broodthaers, Joseph Beuys, Yves Klein, Piero Manzoni and other European conceptual artists. Wilson functions as a curator by working within the limits of the archive, something shared by the American conceptual artist Christopher Williams, whose own work offers powerful examples of how an artist's work can be further appreciated by approaching it from a deconstructive stance. Williams also frequently works with archives, finding in the space of the archive a space filled with potential for deconstruction.

In working with the archive, Williams considers ways to set limits upon his selection process. These hidden decisions screen the work, both framing the work presented while also adding a layer of meaning to the work displayed. For instance, in his work *Angola to Vietnam* * (1989), Williams screens the famous collection of Blaschka glass flowers in Harvard's Museum of Natural History by selecting only the flowers from countries listed by Amnesty International as having experienced 'disappearances' of citizens. Frequently these disappearances involve the politically motivated execution of innocent individuals in Third World countries. That

the groups carrying out these atrocities were often sponsored by Western intelligence agencies adds a political dimension to the work. The shifting frames opened up by Williams' screening process offers one way of thinking about the role of institutions in framing the world. In trying to exclude the political, research institutions often try to represent the cultural ideals of Western society. Framing the world through a screen of categories requires a series of decisions that are necessarily political, even when they seem expressly not. After all, on the surface, what does a collection of replica botanical specimens have to do with anything but flowers? Williams helps to show the many narratives intersecting in his piece, leading to a moment where the categories normally ordering botanical collections are destabilised. It is also a nice coincidence that flowers are the topic of the third part of Derrida's 'Parergon'. Flowers represent, for Kant, an ideal of pure beauty. Derrida, through the ideas at work in the *parergon*, challenges such beauty.

Signing off

The signature is another *parergon*. Neither inside the work, nor outside the work, the signature offers another phenomenon resistant to the everyday ordering of the world by inside and outside. Even if, in the Barnes Foundation, one cannot find labels to anchor the identity of the artist whose work one is considering, one can often find signatures in the work that confer an identity to the work's creator.

At the same time, the signature reveals how a work's identity is always potentially eccentric, always dependent on something residing both inside and outside the work. The signature serves as a type of threshold, existing neither fully in the work, nor outside the work. Sometimes it is presented as existing on one of the objects in the work. Jacques-Louis David represents his signature as if carved on the writing stand in front of Jean-Paul Marat's bath in *The Death of Marat* (1793). Not only is David's name present, but

also a dedication to the deceased, '*á Marat*'. David also does this with the name of Napoleon Bonaparte, chiselling the general-turned-proconsul-turned-emperor's name alongside the names of Hannibal and Charlemagne in *Napoleon Crossing the Alps at Saint-Bernard* (1800–1). In Manet's *A Bar at the Folies-Bergère* (1881–2), the signature appears on one of the labels bearing the logos of Bass ale, a triangulation that has resisted change over the span of three centuries now. In still other cases, the signature is presented in perspective as if organised by the same structure of vision ordering the objects in the painting. In the case of Thomas Eakins, as Michael Fried has brilliantly shown in his *Realism, Writing, Disfiguration: On Thomas Eakins and Stephen Crane* (Chicago: University of Chicago Press, 1987), the signature poses a problematic space. The problem resides in what can be thought of in relation to Derrida's discourse on the *parergon*. Sometimes, Eakins presents the signature as if it belongs in the same world as the objects depicted in the painting, rendering it as floating in three-dimensional space. At other times, he depicts it carved into an object within the painting. Sometimes it simply appears on the painting's surface. In other instances, it appears on the painting's back. The signature poses a difficult question. As a *parergon*, it presents a challenge to the definition of the *ergon* or work. The signature exists outside the work, yet the identity of the work often depends on the signature, as does its material value.

The material value vested through the signature to the work of art moves beyond a question of identity and to a question concerning the values of institutions. In a world of limited resources, the expenditure of material wealth on the visual arts can lead to a questioning of the interests that works of art serve cultural institutions. The work of Hans Haacke, for instance, presents such a form of institutional critique. Haacke often unearths the gray ethical areas necessitated by today's world of culture. He has shown the connections between the Southern art

world in America and cigarette money, one of the largest American slave crops next to cotton.

Kara Walker also explores the legacies of slavery in the post-colonial world. Utilising a medium, the silhouette, often associated with American visual culture in the nineteenth century, Walker uses this marginal medium to cut out forms invoking life in the antebellum South. Appearing in the visual language of illustrated books from the nineteenth century, Walker's large cut-outs take over their exhibition space. The content of the imagery often depicts a world of physical violence and sexual excess that complicates any simple process of labelling perpetrators and victims. Fantasies, nightmares, fictions and traumatic memories, all at the same time, Walker's work explores the intimate relation between racism and violence, as can be seen in the imagery and title of *The End of Uncle Tom* (1995). Walker's work does more than document racial injustices of the past, but continues to force viewers to consider the issue of race within the contemporary moment. Through two-dimensional silhouettes cut from black and white construction paper, she deconstructs the simple oppositions of race ordering American culture both in the past and the present.

On the other side of the Atlantic, Yinka Shonibare explores issues concerning England's colonial past. Drawing upon a different slave product, textiles, Shonibare utilises Dutch wax to address questions concerning the constructed nature of colonial identity. In *Gallantry and Criminal Conversation* (2002), Shonibare suspends a late eighteenth-century carriage in mid-air, surrounding it with headless mannequins dressed in period costuming made out of Dutch wax fabric bearing his printed designs. The mannequins are positioned to visually invoke several simultaneous vignettes of two or more figures performing sexual acts. Rooted in Shonibare's exploration of the eighteenth- and nineteenth-century phenomenon, the Grand Tour, the piece poses questions about the way we represent the culture of the past. Is the Grand Tour, as read from an idealist historian's

perspective, a cultural rite of passage completing the education of an upper middle-class individual and marking him or her as a promising young citizen, or was it a rite of sexual passage leading to experimentation as pictured by Shonibare? The answer, following the logic of Derrida, is both, as the sexual provides a space where, again, the effort of institutions to marginalise a perceived disruptive force appears. The role of institutions in constructing attitudes concerning sexual identity was also explored by Derrida's friend and teacher Michel Foucault in his three-volume study of *The History of Sexuality* (1976–1984).

Shonibare uses Dutch wax to explore the ways that clothing helps to construct identity. Shonibare, in selecting Dutch wax as his medium, points to the contradictions structuring the identity of this material, its appropriation historically, and his own use of it in his installations. The fabric was produced in English and Dutch colonies in Indochina by slave labour. It was then shipped to Holland and England, where it became a garment used to clothe Africans within European colonies during the age of colonialism. Later, many Africans appropriated the fabric during nationalist movements of the 1950s and 1960s. In constructing African identity, a non-African product, one intimately tied to colonialism, ironically becomes a sign of African nationalism. Moreover, this fabric becomes prone to Shonibare's own acts of appropriation. Clothing is one of the examples of a *parergon* cited by Derrida in his discussion of Kant, as in clothing on a sculpture. Shonibare's work raises the question of clothing on mannequins within an installation. Far from inessential, the clothing makes the installation for Shonibare. His work is dependent on the clothing, revealing an interdependence between the *ergon* and the *parergon*.

In a similar fashion, Vanessa Beecroft addresses the *parergonal* structure of clothing in her performance installations, where she presents a group or several groupings of models to a select live audience. The exhibition entails both the live event and the documentation of the event that leads to a series of photographs

45 Framing *The Truth in Painting*

presenting her models, often nude, as in the terms of Kenneth Clark's seminal text *The Nude* (1956). Clark presents the tradition of the nude as an aesthetic genre removing the body from overt sexual significance. Through *parergonal* features, such as the towel and bracelet in the *Aphrodite of Knidos* (350–40 BC), the nude separates itself from the naked. Kant's own work initiates such a discussion through the example of a nude woman wearing only a veil. For Kant, the aesthetic gaze is devoid of any sexual interest in the case of the nude.

Beecroft, however, along with Derrida, complicates the disinterestedness of the aesthetic gaze. Beecroft's work challenges the gender rules normally ordering the depiction of the nude. As a woman presenting live nude women, her approach feeds on a confrontational tradition of art fuelled by discussions of the gaze.

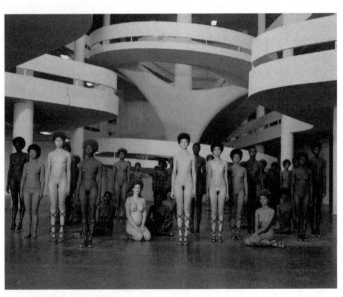

1. Vanessa Beecroft, *VB 50* (2002).

The concept of the gaze appears in several guises within the Western tradition, particularly as it pertains to the nude. If Kenneth Clark's idealist vision of the nude as art for art's sake echoes Kant's own thoughts, T. J. Clark's reading of Manet's *Olympia* (1863; shown here in 1865 Salon) shows how there is always more to what meets the gaze in relation to the tradition of the nude. Beecroft reverses the traditional role of artist and model in the nude. She also instructs and trains her models to ignore the audience. In not acknowledging the gaze of the viewer, Beecroft's work presents a complication of the traditional act of looking within the genre of the nude. Again, *Olympia* provides a good predecessor in the way the gaze comes to frame the nude. Instead of simply looking at photographs of Beecroft's women not looking at us, something implied in all acts of traditional representation at some level, there is a situation, for a few hours, where an audience experiences the denial of its presence by barely clothed women who occupy often unavoidable spots within the historically laden spaces they occupy.

In *VB 35* (1998), for example, Beecroft's models occupy the central corridor of the Guggenheim Museum, the signature space of Frank Lloyd Wright's modernist structure. Daniel Buren had tried to penetrate this space visually in the early 1970s with his vertically erect stripes. Beecroft, in following a long line of visual artists, succeeds by having her models simply occupy this central space by standing erectly still for several hours. Often women in Vanessa Beecroft's work wear items associated with designer labels. In *VB 35*, many of the models wear swimsuits and shoes by Gucci and Prada. Others wear nothing at all. The exposed bodies of Beecroft's models open up a dialog with the field of fashion, aping the appearance of fashion models, while removing the sheen of fashion's artifice through the physical strain of her models. The world of fashion, interestingly, is one of the fields exerting a heavy influence on the world of contemporary art through financial support. From Prada to Estée Lauder, the world of fashion has come to stamp its identity on the world of art. Concerning the

subject of identity, clothes not only make the man, they frequently, sometimes literally, unmake female identity. In the modern world, fashion has often been at the forefront in negotiating issues of identity across visual culture. From Francisco Goya's bandit *maja* to David's toga-wearing *nouveaux riches*, the role of fashion in constructing identity can be seen. In the late nineteenth century the world of fashion went further in posing the eccentric nature of our constructed identities through the advent of the designer label. These labels often provide a mark of authentication when it comes to the value of an article of clothing.

Interestingly, fashion was one of the realms to be affected in the 1980s by the idea of deconstruction. Even if designers were not quoting passages of *Glas*, as Valerio Adami was doing as an artist in the late 1970s, designers were beginning to be self-reflexive, making work that reflected back on itself and its production. In the work of Belgian designers such as Ann Demeulemeester, Martin Margiela and Dries van Noten, items of clothing were presented as if half finished. Paper patterns were left pinned to the fabric. Items normally inside a garment were often presented outside. Whole garments were presented as inside out or falling apart. Margiela, for a 1997 exhibition, even added parasitical bacteria in an effort to undo some of the traditional ideas concerning creativity and function within the realm of fashion. Focusing on decay and literally falling apart at the seams, these garments offer another instance of trying to give deconstruction a form.

While Beecroft subjects her models, friends and sometimes her own family to the gaze of exhibition audiences, James Luna subjects himself to the exhibitionary gaze by inserting himself into a cultural space in his *Artifact Piece* (first performed 1986). First done at the San Diego Museum of Man, Luna submitted his body to the gaze of a museum audience, revealing marks that begin to expose both the reality and the fictions structuring the reception of Native American experience. Through labels, bruises and scars are attributed to fights, drunkenness and clumsiness, inscribing

a narrative that plays on stereotypes of Native Americans. In a room devoted to artefacts pertaining to Native American culture, Luna is presented as a living artefact. The idea of a living artefact embodies a deconstructive logic that one could relate to other oxymorons from artistic discourse, such as still life, or the French *nature mort* (literally, dead nature). As a living entity, Luna is alive today, but also is presented as something from the past, as an artefact. In a similar manner, in the still life (or dead nature), an object prone to decay, often bearing signs of decay, is presented frozen in time through the image. Between life and death, between reality and its representation, Luna's work focuses on the role that labels play in framing our construction of cultural images. In the case of European Americans, cultural institutions often elide the history of oppression that marks the United States' ascent as a world power, as well as the continuation of this oppression.

Marginalised in the process of this ascent as a people, Luna, as an artist, uses his position to take apart many of the stereotypes pertaining to the construction of Native American identity within American popular culture. He reframes his body with labels that identify cuts and bruises within a narrative built around cultural stereotypes. The labels may bear authentic information or they may bear inaccurate information. Presented as labels, they take apart cultural labels. In the context of Luna's piece, they raise questions about the role of institutions in constructing the information that we as museum goers imbibe. Luna, like Derrida, asks that we read more critically, especially when it concerns institutional representations of the Other. Luna's work utilises a *parergonal* site, the label, as a means of questioning the values structuring our cultural traditions, challenging the role of institutions in framing the past.

Chapter 3

These boots were made for walking

If institutions help frame the past, part of the work is done by individuals within institutions. In relation to *The Truth in Painting*, we saw how Derrida uses Kant's discussion of the *parergon* to enact a deconstructive reading of Kant's text. Through the *parergon*, Derrida shows how the grounds of identity as defined in the Western tradition rely on tenuous structural oppositions, such as the relation between inside and outside. In activating the *parergon*, Derrida's reading of Kant brushes up informatively against the work of several contemporary artists.

In this chapter, I want to look at questions concerning the construction of identity through art and the deconstruction of values associated with identity in the work of Derrida. In doing so, we'll examine Derrida's fourth essay in *La vérité en peinture* (*The Truth in Painting*), 'Restitutions de la vérité en pointure' ('Restitutions of the Truth in Pointing'). The title of the essay represents an intentional misspelling of the word *peinture* that forms part of the book's title. Derrida's use of *pointure* refers to a process involved in printmaking (integral to the literary and visual arts), and, in relation to shoemaking and glovemaking, the number of stitches in a shoe or glove. In printmaking, a small blade, the *pointure*, punctures the paper, while, in shoemaking and glovemaking, stitching the material punctures the leather repeatedly. The leather is also punctured or pricked to make the eyeholes through which shoelaces are strung. The concept of the *parergon*, discussed in his essay on Kant, reappears here in the

form of a constructed dialogue concerning a painting of boots by Van Gogh. The reason for this painting becoming a site for the parasitical activities of deconstruction is a conversation that Derrida frames around two essays. The first is Heidegger's highly influential essay 'The origin of the work of art' (1935). The second is a short piece by the American art historian Meyer Schapiro, commenting on Heidegger's essay and the identity of the work by Van Gogh that Heidegger cites within it.

The essay itself takes the form of a polylogue, a type of literary form Derrida began to use more and more starting in the mid-1970s. Texts taking this form include not only 'Restitutions de la vérité en pointure', but also *Glas*, *Memoirs of the Blind* and *Right of Inspection*. Derrida's interest in literary form stems from his engagement with literary modernism, especially the symbolist poet Stéphane Mallarmé. Mallarmé wrote several pieces that were concerned with the text's material forms, sound and appearance, as expressive units – a topic Derrida discusses in one of his important early texts, *Dissemination*. If a dialogue takes place between two people, a polylogue takes place between n+1 voices.

We can read Derrida's essay as many conversations in the same writer's head or an open-ended conversation with as many voices as we readers choose to invent. Derrida presents his own thoughts as fragmented and conflicted. In staging a textual exchange between Heidegger and Schapiro, Derrida draws upon the historical framework surrounding each writer's text. Heidegger's text was first brought to Schapiro's attention through his Columbia colleague Kurt Goldstein, who came to Columbia after fleeing Nazi Germany. At the same time, Heidegger not only stayed in Germany, but, as was well known within the philosophy community, also briefly became a member of the Nazi party after taking the chair in philosophy formerly held by his Jewish mentor, Edmund Husserl. Derrida, as both a philosopher and a Jewish intellectual, is simultaneously an heir to the work of Husserl, whose writing on phenomenology formed the focus of Derrida's

early research into philosophy, and an heir to Heidegger, whose own work informs Derrida's project of deconstruction, as noted earlier.

In mirroring Schapiro's act of dedicating a work to a Jewish colleague, Derrida dedicates his own text to 'J.C...sztejn', short for Jean-Claude Lebensztejn. Originally, Derrida published his essay in an issue of the journal *Macula* dedicated to articles on Heidegger and the shoes of Van Gogh. In taking up a minor essay by a major art historian concerning a major philosopher, discussing an artist as popular as Van Gogh, Derrida reveals structures ordering academic discourse on art. Derrida also raises larger questions concerning restitutions, both revelling in moments of great literary absurdist hilarity and also introducing moments touching upon issues of restitution regarding the Holocaust.

The polylogue format provides a means for Derrida to express his conflicted feelings on the exchange between Heidegger and Schapiro, finding moments when each author constructs an identity for the owner of the boots in the painting, and, moreover, identities that cannot be adequately revealed necessarily because they exist in a painting. As one of Derrida's voices constantly challenges, we cannot even say safely that they are a pair, or, rather, once we start thinking of them as a pair, we begin projecting a series of structures distancing us from the work – a question that is also central to Heidegger's reading of the work of art in his own essay.

Derrida points to moments when Schapiro seems to be projecting an identity onto the boots. Schapiro reads them as being the shoes of Van Gogh and that by the time of the painting he was a man of the city. These assertions ride solely on Schapiro's authority as an art historian. Moreover, this pronouncement is also a renunciation of Heidegger's reading of these boots as belonging to a peasant woman. Or at least, that is how Schapiro frames Heidegger's reading. As Derrida shows, Schapiro does not seem to have read Heidegger very carefully. Or as Derrida reads Heidegger. Still, as another voice in the polylogue suggests, the image of a

peasant woman relates to a nostalgic rusticity in Heidegger's philosophy that troubles Derrida. Such rural rusticity is troubling because it echoes some of the rhetoric used by the Nazis in constructing their ideology – an ideology that Heidegger briefly fell in love with. Part of this ideology was constructed visually through a conservative realism. It also led to the violent suppression of modernist art, which it labelled 'degenerate', as in the infamous 1937 Exhibition of Degenerate Art.

At the same time, one of Derrida's voices discounts Schapiro's attribution of an identity to the pair of boots in the painting as simply a projection. In doing so, he does not find fault in Schapiro but, rather, within a whole tradition of art history that has been guided by the values of philosophy. In attributing an identity to the owner of the shoes within the painting, Schapiro gestures toward a larger tendency to attribute identity within the visual arts. Texts on art focus on the artist's identity, finding this identity attached to the work of art. The attachment of identity to an object forms another *parergonal* supplement to the work of art. Never complete in itself, an identity is attached to the work in both the texts by Heidegger and Schapiro.

Identity trace

Identity is dependent on some mark of authentication existing outside the subject. For instance, to prove my identity I have to show an identity card. On this identity card, there is a signature, one that I am supposed to be able to replicate time and time again. The card also constructs my identity through a series of measurements and, at times, other physical traits and marks, such as fingerprints. Through an external document, a birth certificate, my identity is tied to a particular corporeal self. Even if all these documents can be forged. In a culture of identity theft and national security, the eccentric structure of identity is demonstrated on a regular basis. If the signature is a mark of identity, the marks that we make as artists all contribute to our identities as individuals,

making our acts of mark making intimately involved with the construction of the Self. The word 'mark' appears, at times, as *marche* in the French text. The word *marche* links up with other French derivations of this term, such as *la marche,* or 'walking', possessing allusions to Derrida's essay, as well as relating to another visual term in this text, *trait* or 'trace'. All these verbal (and visual) traces are signs of difference or *différance.* Either they are significant marks made by someone other than myself or they are marks made by me in the past, even if it is a recent past.

For Derrida, any mark is a physical trace possessing the potential to be part of a structure of communication. In *The Truth in Painting*, the mark takes on an array of forms that can easily be grasped visually. In some instances it is termed a *tâche* or 'stain', something that can be an identifying mark to a work of art. We can think of *tâche* in relation to a visually similar word in English: 'touch'. One recognises the artist's hand in the displaced physicality of her or his touch. The body of the artist is literally displaced through the touch or *tâche* left on the canvas.

Conferring identity through a series of physical marks bearing witness to the absent presence of the artist's unique body, the quality of these marks also has to be sufficiently repeatable to become associated with a particular artist. While this presence is perceived as being in the work, the artist's physical self remains absent, outside the work in traditional art forms. An artist's style is made up of a series of repeatable strokes whose cumulative effect reveals the artist's touch. Touch is also central to the field of connoisseurship – one of the first fields of academic study in regard to the visual arts.

Connoisseurship involved the quasi-scientific study of an artist's work by recognising the marks or forms significant in determining the identity of an artist through his or her style. Often weight was given to marks the artist would unconsciously repeat. Ears, noses, mouths and other facial features could be perceived as critical in revealing the identity of an artist's work, especially when

there was no signature or document to support the work's identity. One of the foremost figures to write about connoisseurship in the nineteenth century was Giovanni Morelli (1816–91). Interestingly, Freud was intrigued by Morelli's work, writing about connoisseurship under a pseudonym. Morelli's work serves as a prototype for the psychoanalytic theories of the unconscious that Freud, at this time, was staging through his readings of the work of Leonardo and Michelangelo Buonarroti. To illustrate the unconscious during this period of theoretical exploration, Freud used an object that has clear visual connotations. He referred to this object as a mystic writing pad, an object often given as a toy for young children. An Etch-a-Sketch is a more contemporary version. You write by making a mark on a clear sheet of plastic with a stylus, pressing into a slab of wax and leaving an impression on the surface that can be erased as soon as the plastic sheet is lifted. A more permanent mark would be left on the thin slab of wax underneath. For Freud, the cumulative marks are the repeated psychic impressions made on the unconscious, while the plastic page that becomes clear again is akin to the conscious. Derrida discusses Freud's idea in *Writing and Difference* ('Freud and the Scene of Writing').

For Derrida, identity is constructed out of a series of repeatable marks that are not repeatable by anyone else. The crux of identity, as presented through the notion of the signature that Derrida develops, has its basis in being able to be repeated or copied. The contradictory structure of the relation between signature and identity was presented once again in 'Signature Event Context'. Derrida discusses the way the signature on a cheque requires a countersignature. One has to countersign one's signature, proving that one's signature matches the one stored in the bank's files, or on the cheque itself in the case of traveller's cheques.

Here again we encounter an example of how the original is dependent on the copy. The copy authenticates the original. Moreover, in a culture where the means of duplication are

omnipresent in the form of answering machines, cellphones, printers, iPods, PSPs (Playstation Portables) and other virtual technologies, we confront a situation where the authenticity of valuable material objects is tied to a piece of documentation. For instance, a limited edition collectable item requires a certificate of authentication. In the case of American sports, baseballs involved in the pursuit of record feats have been given an official stamp of authentication to determine their authenticity. Of course, what makes the stamp official is never questioned. In the case of works of art, documents are used to verify the authenticity of the work in question. It goes without saying that documents of authentication can also be forged.

A mark, in its structure as a replicable phenomenon, is made to bear ideas its material form cannot support. The repeatable identity of a mark can, however, lead us into misrecognising a work of art. We impose structures familiar to our gaze when interpreting marks, leading us to tell stories that may have no more than one or two dimensions. In his staged confrontation between Heidegger and Schapiro, Derrida offers several different structures of interpretation, ranging from the psychoanalytic to the philosophical. For Derrida, however, none of these systems can adequately account for Van Gogh's painting. One cannot even successfully identify the shoes as being a pair without already imposing some structure onto the shoes.

The desire to read the shoes as a pair may indicate a desire to grant an object, the painting, a quasi-subjectivity. Heidegger and Schapiro are both guilty of attaching identities to the shoes that reveal their own attachment to particular narratives concerning the Self. For Heidegger, it is a question of a nostalgic longing to connect with the physical world. He sees the boots as a mediator between human experience and the earth. Shoes mediate our relation to the ground, connecting us to the earth, even as they protect us from the elements. Heidegger's nostalgia

for peasant shoes also reflects a spiritual fatalism, expressed in certain works by Jean-François Millet. At the same time, Schapiro projects the identity of an urban dweller onto Van Gogh. Schapiro's projection is tied to the memory of Goldstein, a displaced German living in the urban jungle of New York. In granting Van Gogh an urban identity, Schapiro merges a part of his image of Van Gogh with Goldstein, the person to whom Schapiro dedicates his essay. Issues of debt and restitution also echo in Derrida's reading of the texts of Heidegger and Schapiro, interlacing his text with theirs around issues concerning remembering and taking and giving accounts of the Holocaust. In Derrida's reading, the events around World War II come to define the attitudes being expressed by both Heidegger and Schapiro, at different times and from different perspectives, through the work of Van Gogh.

Of course, Derrida's own reading is marked by his thought process in 1978, and the themes raised in 'Restitutions de la vérité en pointure' are also addressed in other texts relating to questions of visual culture. The shoe is a visual form that Derrida associates on more than one occasion with the reversible structures of deconstruction. Derrida points to the difficulty of determining the limit between the inside and the outside of a shoe. The shoe is detachable, worn on a foot, and slowly takes on marks of its physical use by that foot. The shoe is a loaded object, having been constructed as a fetish by Freud, as well as by cultures before Freud. The French writer Georges Bataille (1897–1962), who figures prominently in Derrida's essays, discusses the range of cultural beliefs attached to feet and footwear. The shoe, in relation to deconstruction, represents another reversible structure, one of many appearing in Derrida's writing. Umbrellas, mouths, ears, vaginas, anuses, and other enfolded and enfolding structures provide a constant point of reference for Derrida's thought. Many of these examples are thresholds between the inside and the outside of the body. For Derrida, these liminal regions are critical points where the values of Western tradition are up for grabs.

And it is precisely in these liminal spaces, spaces that no longer are defined simply by the categories of 'outside' and 'inside', that Derrida's thought takes hold. No longer simply thinking outside the box, but thinking without a box. As some of the visual examples cited from the last chapter suggest, art often provides a space for deconstruction. In the next chapter, I take a look at some other visual examples that conform – if that is the right word – to a way of visual thinking corresponding to how Derrida thinks and expresses himself through language.

Chapter 4

Fashioning deconstruction

As noted earlier, the two other essays in *The Truth in Painting* were written in conjunction with specific exhibitions by artists whose work was intimately known to Derrida. In writing of the work of his friends, Derrida puts into practice an ethics of friendship that he articulated later in his career, though, as with almost every subject he broaches, his engagement is complicated as it questions a whole tradition of literary and artistic friendship. Titus-Carmel and Adami were not the only artists, however, to become acquainted with Derrida's work in the 1970s.

The American painter Mark Tansey has also made use of Derrida's texts. In some instances he has done so literally, as in *Constructing the Grand Canyon* (1990) and *Derrida Queries de Man* (1990). In the case of *Constructing the Grand Canyon*, the natural wonder is constructed out of layers of text. These texts are appropriations from the work of Derrida and his contemporaries, such as Jean Baudrillard (1929–2007), Roland Barthes (1915–80) and Foucault, who make up some of the camped surveying team. A flag with a 'Y' on it refers to Derrida's presence among the literary scholars at Yale University. Tansey's own reception of Derrida is informed by the period of the late 1970s, when many of Derrida's texts were first becoming available in English and controversy still surrounded deconstruction in literary departments in America.

In *Derrida Queries de Man*, the two colleagues dance on the edge of the abyss their texts have constructed. (Or that Tansey

constructs by accumulating layers of printed text on his canvas). The work of Paul de Man (1919–83) became embroiled in controversy shortly after the literary critic died. The controversy involved a handful of essays on music and literature that the Belgian de Man wrote as a young man during a time when his home country was occupied by Nazi Germany. In these reviews, language reflecting a widespread anti-Semitism was used, even if the texts are only mildly anti-Semitic given the context. Nevertheless, Derrida, always sensitive to the question of anti-Semitism, is pushed into an untenable position, both having to defend his friend and to defend his ideas. Of course, such difficult to sustain positions are where Derrida often does his best work. In a series of texts relating to de Man (*Mémoires: for Paul de Man*, trans. Cecile Lindsay, Jonathan Culler and Eduardo Cadava, New York: Columbia University Press, 1986; *Mémoires: pour Paul de Man*, Paris: Galilée, 1988), Derrida manages to address critics of de Man and offer a rune-filled memorial to his friend, while extending the project of deconstruction beyond the limits of literature and philosophy.

Deconstruction reveals that there is no innocent eye. Derrida's texts can be framed in such a way that they present a compelling argument concerning how any discourse on the visual arts is necessarily constructed from the start. Discourse marks the subjective structures that each viewer brings to a work of art, however minimal that discourse may be. All the essays in *The Truth in Painting* raise a question concerning the frame. As four sides to the same discursive frame, they assume divergent literary forms. They remain integrated, however, through Derrida's literary inventiveness. The four essays form interconnections not only to each other, but also to other texts from Derrida's *œuvre* or body of work. As a result, earlier texts become open to new readings, especially in relation to the visual arts. In this manner, a text is never complete, as interpretations and new texts come to contribute to what a work is thought to signify at a particular

time and place. Through structures of artifices, such as the twenty-four framed occlusions (marked by exploded jointures) ordering the movements in his Kantian aria, 'Parergon', Derrida uses literary form to reveal the artifice of the conventions he is expected to work within. These self-reflexive gestures can sometimes be allusive on first reading, but they accrue significance over the course of reading and rereading the text and the ample commentary on it.

In making us aware of the materiality of language through his literary artifices, Derrida forces us to pay attention to our act of reading. Derrida also acknowledges his authorial presence, even as he discusses the way that presence is conferred through structures built around absence. Words come to stand in for the thought of someone now deceased. Derrida's presence is never fully present. His presence, as an author – indeed the presence of any author – is always subject to a process of reframing that his own texts dramatise.

Within the tradition of philosophy that Derrida is reading, the visual arts are often relegated to a marginal space. That is to say, within the hierarchy of fields structured by the dominant discourse of the nineteenth century, philosophy, the visual arts are often depicted as of little importance when compared to fields, such as – well, philosophy. If one of the gestures of traditional philosophy is to assert its dominance over all other fields of human inquiry, then the example of the visual arts offers many opportunities to see the potential for deconstruction to happen or take place.

Innocence lost

Beauty, in relation to art, is presented as something that is purposeless in Kant's aesthetic, but that is precisely its purpose: to have no purpose. Out of all the other objects in the world, the work of art is the only one that seems to have no apparent purpose. That is its purpose, though. From this comes the popular notion of art for art's sake. Derrida challenges such artistic innocence. There is no innocent eye. Or, rather, the innocent eye is a construction.

Sometimes it is constructed as an image, as in Tansey's *The Innocent Eye Test* (1981).

Although he is nowhere to be found in Tansey's *The Innocent Eye Test* as a direct visual reference, the work is far from being innocent in its associations with Derrida's thought. Tansey's work has been expertly read by Mark C. Taylor (*The Picture in Question*, Chicago: University of Chicago Press, 1999), one of the few writers on Derrida to consider the visual arts. Derrida's thought often challenges the notion of purity. The arts are often considered such a field of purity.

Tansey presents a scene depicting a cow being presented a painting of two cows by the seventeenth-century Dutch painter Paulus Potter, as a group of educated-looking gentlemen in lab coats, perhaps connoisseurs (if I were a connoisseur of connoisseurs), stand attentively observing the cow. The art experts consult a cow to determine whether a work depicting cows is convincingly rendered. For the art connoisseurs, their cultivated gaze cannot judge the work adequately, because their vision is structured by aesthetic discourse. They need an innocent eye, a bestial eye. In the cow's gaze and the anticipation of her reaction to the work of art, we have an echo of a similar story from antiquity concerning an artistic competition between the painters Zeuxis and Parhassios. For the competition, Zeuxis paints an image of grapes, fooling a bird, which comes to peck at the painting. As a result, Zeuxis triumphantly turns to Parhassios and asks him to unveil his painting. Parhassios' painting was already unveiled, however, because he depicted a *trompe l'oeil* veil covering a canvas. While Lacan's reading of this tale of the triumph of the gaze is well known, from a Derridean perspective we can see Parhassios as painting a *parergon*, an object unnoticed, but integral to the ritual already framing a work of art. The veil was used to cover works of art in antiquity as a formality. Parhassios latches onto this formal *parergon* in fooling an expert.

The visual tricks of the *trompe l'oeil* tradition were also mined by Magritte in works such as *The Human Condition* and *The Tyranny of Images* (1929). (Magritte's paintings of boots that are feet or feet that are boots appear in Derrida's 'Restitutions of the Truth in Pointing'.) Subject to a world of endless representations, humans only ever access the world indirectly through signs. There never is an innocent eye.

Tansey, as inheritor of the artistic traditions before him (something accentuated by his parents' background in art history), plays with the traditions and philosophies informing the currents of realism. The realist tradition embodies an idea that the culture of Parhassios and Zeuxis called *mimesis*, a concept Derrida takes apart in his text *Dissemination*, as well as elsewhere. Mimesis is the replication of something rooted in human observation. The tradition of Western mimetic painting can encompass dramatically divergent variations. In the case of Tansey's *The Innocent Eye Test*, the sacred cow is seventeenth-century Dutch naturalism. Such naturalism, in its visual manifestation as realism, could lead not only to the conservative realism of Potter, but also to the radical realism of nineteenth-century artists, such as Gustave Courbet (1819–77). In constructing his realism, Courbet proclaimed that he could not paint an angel because he had never seen an angel.

In opposition to the corrupt vision of art connoisseurs, a cow takes on the role of expert in seeing how well the painting apes reality. Tansey's painting, like most of his mature work, also apes reality. With roots in several traditions of realism, Tansey makes impossible photographs evoking imagery from the recent past. Through style and monochromatic imagery, Tansey's work recalls the appearance of early photographs in mass print media. He also questions some of the foundational myths concerning the genre of realism and its relation to history.

The idea of the innocent eye also recalls the Romantic philosophy of Rousseau, whose work Derrida addressed in *Of Grammatology*. Rousseau's thought offered a renunciation of

institutions as structures corrupting the purity of what Rousseau nostalgically called 'primitive man'. Primitive man, in the form of premodern societies, is the focus to the work of Derrida's other target in *Of Grammatology*, Lévi-Strauss. The idea of the innocent eye in Tansey's work suggests an absurd interpretation of Rousseau's thought and the tenets of realism's transparent ideology. Or, rather, there is no innocent eye. The idea of the innocent eye is connected to the idea of purity that Derrida deconstructs in his earliest texts.

As a structure, *The Innocent Eye Test* already has structural weaknesses that can lead to its collapse. For instance, how is the innocent eye test evaluated? How does the cow convey her approval to us? Why should an animal be fooled by an image? Or, better yet, how come we are continually fooled by images that have real effects upon us, even though they are works of artifice, made objects? In part, we live within a culture defined by an endless selection of spectacles courting our visual pleasure. In the nineteenth century a Romantic longing for oneness with nature marked a great deal of visual and literary experience. For Tansey and other realist painters, realism, in the late twentieth century, meant negotiating an expanded tradition of visual culture necessitating far more sophisticated approaches to thinking through the potential implications that arise from the disparate imagery we consume daily. Such a strategy intimately relates to strategies in the work of Derrida.

Deconstruction and architecture

In 1988 the Museum of Modern Art in New York presented an exhibition of a loosely defined group of architects whose work had been associated with deconstruction in the 1980s. Some of the architects, such as Peter Eisenman and Bernard Tschumi, had already cultivated an intimate association with Derrida's name. The collaborative effort of Andreas Papadakis, Catherine Cook and Andrew Benjamin yielded the book *Deconstruction* (New

York: Rizzoli, 1989). The architects included in this volume are presented not only in relation to the work of Derrida, but also to Russian constructivism.

Constructivism was an artistic movement associated with the early days of the Soviet Union. Many of the overlooked ideas of constructivism hold great relevance to architecture today. For instance, the concept of disurbanisation anticipates concerns of urban growth and suburban sprawl facing the early twenty-first century. Access to the work of these Russian architects has been slow to arrive due to the way constructivism was marginalised by Western survey texts during the period of the Cold War. Visually, the work of Zaha Hadid relates most intimately with the forms of constructivism.

Hadid's drawings of the 1980s are some of the most powerful graphic works of the era. They anticipate the visual explorations of painters such as Matthew Ritchie and Julie Mehretu. Like many of her colleagues, Hadid's early work as an architect primarily exists as works on paper. Through such paper architecture, figures such as Hadid, Eisenman, Tschumi and Daniel Libeskind could challenge the traditional limits of architecture as well as the physical limitations of architecture. The work of Libeskind, for instance, often incorporates direct references to philosophy and the history of architecture, as in *Never is the Center (Mies van der Rohe Memorial)* (1987). His drawings challenge the threshold between three-dimensional and two-dimensional art. Simultaneously, they open up to a fourth dimension, time. The medium of time is explored in music, a point of reference for Libeskind in other drawings from the 1980s, as in *Chamberworks: Architectural Meditations on the Themes from Heraclitus* (1983).

In relation to built structures, the forms of deconstructive architecture often evoke a sense of suspense, counteracting our visual expectations. The most famous example of this in a physical form may be Libeskind's *Jewish Museum* in Berlin (1988–99). In his projects leading up to this building (*The City Edge*, 1987), Libeskind

presented the city of Berlin as marked by a wound, a physical mark that provides another disfigurative representation of deconstruction. As with other agents of deconstruction, the wound renders the purity of the whole by exposing the unstable relation between inside and outside.

For the *Jewish Museum*, Libeskind redesigned the façade of the *Kollegienhaus* (a former Prussian courthouse) to create the entrance to his supplemental addition. First, in entering the *Jewish Museum*, one moves from the Baroque façade of *Kollegienhaus* to an underground corridor, an allusion to the passage underground of Jews escaping from Berlin during the Nazi regime, while also suggesting the process of excavating a buried history of the Jewish presence in Germany. The underground passage, however, does not lead to a singular site, giving rise to multiple end points. One ends in a garden comprised of forty-nine concrete pillars. Forty-eight are filled with dirt culled from Berlin, while the forty-ninth is comprised of dirt from Israel, the state constructed in 1948. The second route ends in a dead end, the Holocaust Void, a massive concrete wall with an opening to Berlin toward the top. The barricade lets in the sounds of contemporary Berlin while blocking access, representing a discontinuity, the loss of a tradition, or narrative, that represents the rupture of the Holocaust, at one level. The last route leads to the exhibition space, passing through a central void traversed by sixty bridges. The emphasis on voids represents the loss of lives during the Holocaust, marking these individuals as an absence, an absence also marked by the inclusion of the names of Jewish Berliners removed from their homes during the Nazi regime. Embodied by a void, this loss creates an absent presence that is redolent with Derrida's own vocabulary of voids, absences and traces a language that itself arises in response to the Holocaust and issues of Jewish identity, of trying to bear witness to the unimaginable and the all too real at the same time. Libeskind, considering the function of the *Jewish Museum* in the late twentieth century, creates a

structure to contemplate what can never be fully contemplated or understood: the magnitude of loss and how these losses have scarred not only Berlin, but the world.

Part of the purity of modernism resided in keeping the mediums isolated from one another. Deconstruction takes apart the structures holding the medium together, as with the frame in painting. Equally resistant to tidy categories, Libeskind's work shows that the barriers between the mediums of the visual arts are never permanent and always permeable. Architecture references music, philosophy, literature and sculpture, while drawings provide a space to consider the experience of the fourth dimension, time, multiplying allusions. In arguing for complexity within simplicity, Libeskind's theoretical writings often cover territory shared by the texts of Derrida.

In the case of Eisenman, Libeskind and Hadid, as well as others, we can see the different ways that deconstruction has impacted architecture. If these encounters have been staged within the framework of institutions such as the Museum of Modern Art, we should also challenge the way these architects construct deconstruction. That is to say, there is more than one way to deconstruct a house. Derrida's thought does not promise any conclusive answers. Rather, his work offers a situational logic resistant to the oppositional ordering of the world structured by Western thought. The relation between architecture and the texts of Derrida that these architects offer is only one way of trying to explore the relation between deconstruction and architecture. Likewise, a consideration of the relation between architecture and deconstruction does not have to come only from one field or the other. It is in resistance to such 'either/or' scenarios that Derrida's logic of 'neither/nor, both/and' takes hold as a parasitical presence residing within the digestive tract of the tradition he takes apart in his texts.

Chapter 5

Comic reversals

As Derrida's thought gained a growing audience in America during the 1980s, there was a fascinating development in a field of popular visual culture whose qualities paralleled the features of Derrida's deconstructive analysis. The field of comic books saw the emergence of a generation of writers and artists who turned upside down the founding principles of the superhero comic. Writers such as Alan Moore, Frank Miller and Neil Gaiman established a new genre of comic book, one providing a critical reflection both upon the history of comic books and upon the relation of fictive comic book worlds to the world within which we as a society live. In graphic novels such as *The Dark Knight Returns* (1986), *Watchmen* (1986–7), *V for Vendetta* (1988) and *The Sandman* (1988–96), these writers instituted a creative practice mirroring the practice of deconstruction. That these projects were often done for one of the two large American comic book companies of the era and that these projects often deconstructed iconic superhero figures, only adds to the achievement of these works.

In *The Dark Knight Returns*, Frank Miller takes apart the highly popular figure of Batman. A mainstay of DC comics from the Golden Age of comics (1930s–mid-1950s), Batman is a masked vigilante who by day is the multi-million-dollar heir to parents murdered by a thief. Driven by revenge, Bruce Wayne takes on the identity of Batman to fight crime. Traditionally, Batman exists in a world where the lines delineating right and wrong are clearly drawn and motivations for dressing up in a costume are addressed only on the most superficial or practical level. In Miller's rendering of Batman, however, the DC universe is set temporarily awry. Challenging the easy idealism of the Golden Age, Miller, who is

also the artist for this book, renders the world of Batman in a dark realism depicting all characters with a shade of gray. Bruce Wayne, in this shadowy world, is an ageing retired superhero, drinking himself into oblivion, popping pills, and putting himself in high-risk situations. Living out a death wish, he finds salvation in returning to his nocturnal life as Batman. Bruce Wayne, as Batman, poses an irresolvable problem around the idea of justice. Batman acts in the name of the law, but beyond the control of the law. He breaks the law to serve the law. The police, for the most part, accede to Batman's presence, because he makes their job easier and does not commit murder or attack innocent people. Batman uses violence to act in the name of the law, while doing violence to the law by taking the law into his own hands. His violence is exceptional, in that it remains an exception to the law.

The other thing marking Batman as a character is that he is human. Whereas countless superheroes in the DC 'universe' have special powers making them superhuman, Batman, being just a highly trained and wealthy human, is the exception and not the rule. The divide between the human and the superhuman is dramatised through the juxtaposition of Bruce Wayne's vigilante alter ego with the ultimate Übermensch, Superman. If Miller renders Batman as an ageing sadist with fascist undertones, he presents Superman as the ultimate conformist, loyal to any badge he sees. Batman takes authority into his own hands and Superman blindly follows authority, allowing for his exploitation by political power. Between these two extremes, the ideals of the Golden Age give way to a fundamental question that the superhero genre leaves unaddressed: 'Who watches the Watchmen?'

This specific question permeates many of the panels drawn by Dave Gibbons for Alan Moore's seminal anti-superhero comic book, *Watchmen*. As with *The Dark Knight Returns*, Moore's *Watchmen* has appeared on the syllabus of many college literature courses. In part, this is due to the crystalline structure underpinning the narrative complexity that Moore's words and Gibbons' images depict. At the same time, part of the success of this graphic novel resides in the way it takes apart the genre of the superhero comic book. Moore does this not by taking on already established superhero figures, but by creating a universe rooted in the

archetypes and history of the superhero genre. The series as a whole tells the tale of the first two generations of costumed crime fighters in America. Gibbons' artwork does a remarkable job of depicting the Golden Age era, in the numerous flashbacks that slowly reveal the pasts of the characters the reader is discovering. In using a retro style, Gibbons provides a visual counterpoint to Moore's own elegiac ode to a nostalgic world of reassuring values.

The reassuring values emblematised by Golden Age idealism are slowly deconstructed by Moore's dystopic realism. He represents the terrifying world that could be if superheroes existed. His heroes are human, all too human, to borrow a phrase from the philosopher Friedrich Nietzsche, one of the philosophical sources cited in *Watchmen*. As humans, the motivation behind Moore's characters is questioned, revealing something fundamentally strange about the superhero character. Namely, what kind of person dresses up in a costume and fights crime? To this question, Moore responds with a cast of psychologically fractured individuals seeking identity through dressing up as someone else. Moreover, what makes his world of heroes unique to the genre of the superhero comic is that all the heroes in *Watchmen* are human, save one. Their powers are acquired through a combination of training, strength, technology and will. As humans, they have exceptional ability, but none of them are truly beyond the human. Dr Manhattan is the only truly superhuman being. Through this juxtaposition, Moore explores the relation between the superhuman and the human, exposing a world of darkness lurking beneath the mask of the traditional superhero comic.

The nihilistic vision of *Watchmen* points to a darkness at the heart of the archetypal superhero character. Through the figure of Rorschach, Moore can explore the relation between the human and the inhuman. Rorschach makes Miller's Dark Knight look like Casper the Friendly Ghost on Prozac. Undoing the superhero genre, Moore does not heighten the gap between the superhuman and the human that traditional comic books depict. For instance, Superman is infinitely more powerful than a human. He has also been endowed with a code of ethics making him a sworn defender of the Earth. In *Watchmen*, Moore points instead to the intimacy

between the superhuman and the human to the inhuman. In adding just a touch of realism into the mix of the traditional superhero formula, he can take apart the easy idealism of comic books, while simultaneously making us question our attraction to escapist literature.

Moore achieves this not only with the graphic novel as a whole, but also through the comic book within the comic book appearing in regular intervals of the larger narrative. Within a world of costumed crime fighters, there is no longer a need for superhero stories, so horror comics become a popular genre. Specifically, Moore depicts a young boy who reads a macabre pirate tale that weaves itself into the larger narrative of *Watchmen*. What appears at first to be escapist literature takes on the role of a meta-commentary on the larger narrative. In a similar fashion, Moore asks a question that had not been posed in the tradition of superhero comics. What if superheroes actually existed? Far from utopic, Moore presents a world ever on the brink of chaos, nervously asking: 'Who will watch the Watchmen?' Taking this quotation from Juvenal (60–127 AD), Alan Moore places it at the core of his comic book, while making this question resonate for a world with superhumans, as well as a world without superhumans – the world we inhabit.

In Neil Gaiman's highly successful *Sandman* series, marginal characters from the DC universe become protagonists in a world of eternal beings all bearing names beginning with the letter 'D'. Among the immortal beings are the title character, Dream (aka the Sandman), Death, Destruction, Desire, Despair, Delirium and Destiny. Gaiman, in combining his own creations with disused figures from the DC universe, was able to appropriate the genre of the supernatural comic book to tell carefully crafted tales drawing upon a wide array of cultural allusions. In doing this, Gaiman, like Miller and Moore, helped to blur the line between literature and comic books. They revealed how a minor form of popular culture could be elevated to a powerful expressive medium. Their approach, in this manner, is similar to Derrida's approach to deconstruction. Derrida focuses on the margins of philosophy, finding in overlooked texts and passages concepts that problematise the very foundations of philosophy. Gaiman, Miller, Moore and

others helped to transform comic books from an adolescent distraction into insightful works of narrative art.

In bearing a relation to the work of Derrida, these authors are not necessarily taking from Derrida's work directly, but the procedures we can see at work in their creative activities bear a resemblance to some of the procedures we can see at work within Derrida's texts. First, there is often a focus on a marginal element within a particular structure. In *Sandman*, this manifests itself in the appropriation and use of marginal figures from a fictive realm. Second, the oppositions ordering the structure are often blurred. Within the comic book genre, this is done by blurring the line between good and evil. Third, there is often an attempt to push situations toward a limit case scenario. In *Watchmen*, there is only one superhuman being, but this allows for a deeper consideration of the relation between the human and the superhuman. Considering limit cases can also allow one to see the absurdity of the entire genre. Nonetheless, at the core of these works and others by these writers, there is a serious exploration of the possibilities for the comic book medium as a communicative tool within visual culture.

Pop goes the easel

The use of comic books as a point of reference in painting has a long history, and here too we can find facets to the use of this popular visual material that forge a potentially rewarding relation to the work of Derrida. Comic books, in particular, were used by artists to challenge the hierarchy of images reigning over traditional visual culture. The British Pop movement in the 1950s initiated the appropriation of images from comic books as a form of visual expression. Artists such as Eduardo Paolozzi, Peter Blake and Richard Hamilton co-opted images from American popular culture, ruffling the feathers of the artistic establishment in England. Comics and other items of American popular culture were viewed with disdain by the cultural establishment. In choosing to embrace American popular culture, these young British artists challenged the underlying values beneath the tradition of art they had inherited, a process mirrored in Derrida's own deconstruction of the tradition of philosophy.

The use of comic book imagery in American art emerges in the early 1960s with the advent of the New York pop artists. From Andy Warhol's appropriation of Superman and Popeye to Roy Lichtenstein's ubiquitous blown-up comic book panels replete with imitative Ben Day dots, pop art embraced the use of popular culture as a subject for art. Artists, in doing so, challenged not only the values associated with art, but also the values associated with popular culture. In accepting the imagery of the dominant consumer society of America, these artists held up a mirror to the world of post-World War II American prosperity. Pop artists, in this manner, were realists, but in their lens of realism was reflected a loss of the real as America became more and more inundated with popular media. Instead of railing against this loss, pop art used the imagery of popular culture to pose questions concerning the role of fine art within a growing world of media sensation.

The use of comic books as a point of departure for artistic expression within the fine arts continues, as can be seen in the work of American artists such as William T. Wiley, Raymond Pettibon and Robert Williams. Wiley works with imagery culled from a range of visual sources. In conjunction with these images, Wiley incorporates passages of allusive text. Often these texts comprise playful puns, a linguistic characteristic his work shares with Marcel Duchamp. His playfulness is also often coupled with a consideration of serious issues. Wiley, at times, expresses this duplicity through the inventive caricatures he utilises in his work. Two recurring motifs representing technology are given the names 'M.A.S.U.' and 'M.A.K.U.', acronyms standing for 'machines are saving us' and 'machines are killing us'. Wiley's work refuses a simple stance either for or against technology. Instead, his painting demonstrates a thinking that can be related to the work of Derrida, residing in an ability to perceive the world in terms of 'both/and', instead of 'either/or'. In rejecting an absolutist stance in relation to technology, Wiley's work opens up the possibility of a discussion concerning our complicated relation to technology and our inability to simply escape its effects, for these effects are always looming over us.

In the work of Raymond Pettibon, several of the traditional assumptions concerning two-dimensional work are undone.

Instead of showing large paintings, Pettibon shows small drawings. Instead of focusing the viewer's attention on a singular work, Pettibon disperses his themes through multiple works, offering no singular focus. His drawings utilise a wealth of allusions to popular culture and high culture alike. In breaking down the relation between high culture and low culture, Pettibon's drawings put into practice ideas that can be found within Derrida's work. Marginal within traditional discourses of art, drawing becomes a medium providing an opportunity for a potentially insightful discussion concerning the role of art within contemporary visual culture. Pettibon's work has a cumulative effect. Not relying on the singular gesture, Pettibon's work is the sum of many images whose connections and interconnections are left to the viewer to make. In this way, there is a parallel to the experience of reading Derrida's texts. Derrida's exploration of a text often relies upon the repeated consideration of a particular word embodying a logic echoing with ideas found in other texts he has analysed. Derrida's texts rely on an open-ended system of allusions to ideas whose effect is felt cumulatively, as well as singularly.

Robert Williams' work also attacks the traditional hierarchies of art. His work alludes to surrealism, the history of art, hot rod painting, tattoo art and other traditionally denigrated mediums. His work takes an absurdist approach in rendering multiple levels of self-mocking, self-critical images. If modernist aesthetics dictates an approach of 'less is more', Williams' imagery takes on an attitude of 'more is more'. Part of the process of deciphering the comic chaos of Williams' paintings resides in his use of titles accentuating the hilarity of his work. His paintings usually bear three titles instead of the customary one. The multiple titles are constructed for different fictive audiences. In one instance, a title to his painting reads as follows:

The Cartoon Disease
Scholastic Designation: Satisfactory Mental Health is Predicated on the Self-Denial Standard that Abstraction is Anomaly and what a monkey sees is what a monkey will do, hence the liberties expressed in cartoons expose the supple minds of children to the curse of the three fingered glove

Remedial Title: Pantyhose and Shorts Nibblin', Pulp-Paper Goons
aren't for Junior and Sis

One of the images attached to this title depicts a young boy being
scolded by his parents for reading a comic book. The scene evokes
the ideal home presented in American sitcoms of the 1950s. The
image suggesting that father knows best, however, is overwhelmed
by irrational imagery depicting the consequences of reading comic
books. We see the same young boy with drool coming out of his
mouth, as his brain has literally exploded out of his head. The
brain reveals the damage done by reading comic books, as it is
split in half, indicating the additional effects of drugs, alcohol
and other forms of imagined depravity that comics may lead the
young to (from the perspective of adults). While the visual imagery
conveys this absurd narrative, sense can only begin to be made
of the imagery by also turning to the title of the painting.

As a result, Williams activates a space traditionally marginal
to the work of art, but integral to helping the viewer identify the
work. While outside the painting and marginal to the image, the
title provides vital information. It is by looking to the titles of
works that most viewers gain information concerning the work
in question. This points to the importance of titles and labels as
things that add to the work, while being outside the work.

In focusing on the marginal, Derrida does not simply point out
something that has been marginalised. Rather, he looks at how
something becomes marginalised in the first place, as well as
why something is marginalised. He then reveals how the structure
being examined depends upon this marginal element. In the
process, he leaves the structures he occupies irrevocably
destabilised. By pulling on a singular string, the entire fabric of a
system becomes undone, unravelling around its founding principles.

The pervasiveness of deconstruction as a phenomenon in
visual culture is revealed by the way we can see these processes at
work in the genre of the superhero comic books we've examined
here. We can also see in the act of appropriation, as it appears in
the work of artists, a means of breaking down the relation between
high culture and low culture. In both instances, a traditional
structural relation is destabilised. In the case of comics, the

possibilities of a low genre of literature to utilise high literary concepts are revealed. In the case of artists appropriating comic book imagery, we see how the relation between high art and low art is blurred. No longer can one safely keep high culture and low culture apart. Moreover, it is only through institutional force that such cultures were ever able to be kept separate. In destabilising the opposition between high and low, the artists considered in this chapter, each within their own field, find ways of putting into practice ideas intimately related to the approach that Derrida takes to the texts he reads.

Chapter 6

Deconstructing the domestic

In 'Restitutions of the Truth in Pointing', there is another element to shoemaking beyond the term *pointure* that makes it of interest to Derrida. The wooden prosthetic used to 'form' a shoe during its construction embodies conceptually one of the contradictions residing within the system of Western thought that Derrida is taking apart. The wooden 'form' comes to stand in for the absent human foot. The wooden 'form' is a construct that comes to stand in for the individual. It provides a structure for the shoe before the foot comes to enter it. In this way, it bears a parallel structure to identity. Identity is a 'form' that comes to stand in for the individual, as in the nine 'malic molds' 'form'-ing the male protagonists of Duchamp's *Bride Stripped Bare by Her Bachelors, Even* (1915–23). Structures of identity pre-exist the granting of identity to individuals. The wooden 'form'/foot connects to other objects relating to visual forms Derrida discusses. There are tympanums (referring simultaneously to architecture, music and the ear), postcards, mirrors, crypts, mystic writing pads, spectres and a whole array of phenomena evoking something from the realm of the visual, if not the visual arts.

In his essay on the visual art of the fringe surrealist actor and poet Antonin Artaud ('To Unsense the Subjectile', trans. Mary Ann Caws, in Jacques Derrida and Paule Thévenin, *The Secret Art of Antonin Artaud*, Cambridge: MIT Press, 1998), Derrida focuses on a small object used in printmaking, the subjectile. Derrida uses the subjectile as a bridge into Artaud's thought and art. While

appearing only a couple of times in Artaud's written work, the word 'subjectile', in conjunction with the actual object, again offers Derrida a way to take apart one of the struts of the Western structure of identity.

The subjectile is a piece of cardboard used in early printmaking devices. It served as a support for the material being printed. Integral to the process, it was later discarded. The subjectile functions, in this way, like the structure of the Western subject. For a thinker such as Artaud, who ended up spending a vast part of his life in an asylum, thinking beyond the subject lent itself to an invented and inventive language, making it difficult to decipher at times what Artaud exactly means. The ambiguity of Artaud's language provides a space where Derrida can read Artaud's visual and literary worlds of representation against the grain of Western tradition. He does this by taking something relatively trivial from texts by a thinker who is marginal to the Western tradition. Derrida frames the threat that Artaud's thought poses to this tradition. At the same time, however, Derrida shows Artaud's thought to be dependent upon the Western tradition he seems to critique. In his oppositional stance, Artaud ends up brushing right against the tradition of Western metaphysics that he is trying to go beyond.

At times, Derrida owns up to his parasitical dependence on the Western tradition he deconstructs. In finding physical manifestations of a deconstructive concept within the subjectile, there are several elements to consider. The first is the meaning of the word. The subjectile offers a way into thinking how we construct an identity in relation to pre-existent forms. We construct an impression of our Self through the support of the subjectile. At another level, the subjectile is something absent without which what we are gazing at would not be present. A mark has been made against it, an impression taken and, like Freud's mystic writing pad, the subjectile bears a history of accumulated marks. These physical traces are the absent

presences left by the impressions our acts of creativity leave upon the discarded tools from which our images and words are produced. The subjectile also relates to the *parergon*. Detachable, the subjectile is not part of the work, but without the subjectile the work would not be possible. If we think about the process of making visual art, there are any number of examples that also link up to the logic lurking within Derrida's use of *pointure*, subjectile and other related terms. In part, the force of these discarded artefacts reside in their testimonial to how humans approach the world.

No place like home

In sculpture, the work of Rachel Whiteread takes up the forgotten forms used in the process of casting, inverting the traditional approach to making sculpture. Whiteread casts spaces that normally would be used to replicate three-dimensional forms. Such moulds would be discarded after being used to create the sculpted work. In making this discarded material her primary means of expression, Whiteread finds a new way of considering the cast, while opening up potential connections to the work of Derrida.

Early in her career, Whiteread cast the space underneath chairs and beds, within bathtubs and the negative spaces of other domestic fixtures. The resultant forms evoke small, intimate spaces that affect a sense of displacement. In seeing the solid space of a bathtub, one becomes aware of a perceptual difference between our experience of occupying space and the actual volume of that space made physical. The disjuncture between these two perceptual experiences can lead to other associations, such as childhood memories of fitting into the spaces beneath chairs and beds. The sophistication of Whiteread's process grew in ambition, something to which her famous work *House* (1993) attests.

In *House*, Whiteread cast the interior space of a London row home from the post-World War II era. The work was executed when

Whiteread was one of the candidates for the prestigious Turner Prize. The Turner Prize is given to the winner of a select competition among young British artists. The prize is one of the features that has helped to generate the visibility of young British artists. In the case of Whiteread, the controversy surrounding *House* overshadows much of what made Whiteread's work so compelling. That is to say, in a culture filled with so much spectacle, it is a rare accomplishment for ambitious art to gain so much attention.

Originally intended to exist for just a few months, *House* was ultimately destroyed after just a few weeks, due to the controversy the work cultivated. *House* was located among a block of row homes that were being torn down to provide for a public park. Whiteread was given permission to cast one of these homes for a temporary site-specific sculpture. Some of the people in the neighbourhood complained, leading to press coverage that only fuelled the spectacle surrounding *House*. Among the more memorable comments was the obligatory response that if Whiteread's work was art then 'I am Michelangelo'.

Whiteread's work, however, touches on how we are not Michelangelo, but we *are* impacted by the spaces in which we exist – spaces we often don't consider because they are so familiar. In our daily lives, we experience ourselves surrounded by a space we call home. The structures we house are in turn structured by the daily rituals marking each room. The way we shave in the bathroom. The way we watch television in the living room. The way we eat in the dining room. The way we cook in the kitchen. The way we prepare for bed in the bedroom. These procedures go unnoticed, as do the spaces making up our quotidian existence. Whiteread casts the space through which our existence daily courses, or, simultaneously, a space she relates to her own process of socialisation. She negotiates a space between individual identity and the identities forged by nation and class. In doing so, she makes a familiar space seem unfamiliar.

In German, the word *heimlich* or 'home-like' connotes the familiar. In a famous essay ('The Uncanny', 1919), Freud wrote about the origins of the word *heimlich*. Freud discovered, in the process, that the word for 'familiar' also originally contained the sense of the unfamiliar. In unearthing this ambiguous origin, Freud explored his concept of the *unheimlich*. Translated as 'uncanny', the *unheimlich*, or un-home-like, occurs when we experience something familiar as being unfamiliar. We enter into a space and it seems oddly familiar. Or, perhaps, we walk into our house and it seems unfamiliar. For Freud, the genesis of his exploration of the *unheimlich* is related to other powerful visual concepts in his writing, such as the doppelganger.

In the case of Whiteread, her work makes the home literally *unheimlich*, un-home-like. No longer a functional space, the physical space of daily existence is made solid. Often bits of the wallpaper appear in Whiteread's castings, as well as remnants from the home's infrastructure. These bits of the home's frame offer a trace bearing witness to the absent presence of the domestic space that Whiteread's sculpture both is and evokes as being absent.

In casting a house, Whiteread does not just reverse the relation between cast and sculpture in a way that mirrors Derrida's process of reversing structural oppositions. She also destabilises the relation between inside and outside. Revealing the permeability of the relationship between inside and outside is one of the recurrent procedures Derrida's texts explore. In the case of the home, the destabilisation of the relation between inside and outside connects to the notion of public and private. The home is a private space that protects us from the public gaze. In a culture of surveillance technology, instant messaging and real-time communication tools, the barrier between public and private is, however, constantly blurred. We seek protection from telemarketing, spam, computer viruses, infomercials and other intrusions invading our private spaces.

In *House*, Whiteread makes private space literally public. In doing so, her work opens up to potential psychological associations. What happens in the privacy of the home is sometimes buried in the basement of the Self. If Whiteread's *House* touched a nerve, it could be suggested that it did so because of the powerful formative associations the row home had not only for Whiteread, but also for numerous English residents. Such associations are marked by elements of difference, dependent on generation, for instance, or gender. Nevertheless, this is one of the great insights that can be gleaned from Whiteread's work. As a ghost-like form, *House* is like the prosthesis used to form a shoe. Each shoe or individual formed by the house is left with an impression marking her or his individuality in spite of the homogeneous structure making such an impression possible. That is to say, the same type of architecture can produce a world of very different people with very different associations. The strength of these associations has to do with how the home structures who we are as individuals and as a culture, as well as the way that these structures potentially delimit who we are, becoming not only our homes, but also our prisons.

What Whiteread does to a British row home, Gordon Matta-Clark does to a suburban New Jersey home. In *Splitting* (1974), Matta-Clark received authorisation to do a temporary site-specific sculpture in suburban New Jersey, utilising a middle-class home slated for demolition. Matta-Clark carefully shaved down one half of the home's foundation. He then proceeded to cut through the home, splitting it down the middle. After making this cut, the house settled onto its new foundation, causing a gap that Matta-Clark's photographs document. As with *House*, a domestic space is made unfamiliar. In addition, the fragility of the home becomes apparent in *Splitting*. In cutting open a house, Matta-Clark is not just exposing the interior of the house to the outside world, destabilising the relation between inside and outside; he also exposes the beams providing the very structure for the house in the first place.

Indeed, a house is about the first place, the place that nowhere else is like. But how does a place like home arise? By building a structure on a piece of land. If our experience originates in the houses we were raised in, these houses are structures built on places existing long before we ever came into existence. The house is a structure that makes familiar a location that is otherwise indifferent to us. The spaces we live in, as we move from home to home, become our 'homes' only through our making them over into our image of home. When we first move into a new living space, the space is empty. We proceed to fill it up with our belongings, slowly making the space home. But this home is a construction. In Matta-Clark's work, the emptiness of the home suggests the transitory state of a space filled with absent presences, the absence of the *parergonal* objects that once filled the home. That is to say, a home is not defined by the struts and drywall making up the rooms, but by the people and objects within them.

Domesticated violence

In the experience of the uncanny and the work of Whiteread and Matta-Clark, we can see that domestic space is more tenuous than imagined. If the stability of our concept of the home may be destabilised by the simple interventions initiated by Whiteread and Matta-Clark, we can also think about how little it takes to unbalance our sense of relative domestic security. The power of the domestic may be potentially tied to the psychological power of genre cinema that utilises the home as a site of terror. For instance, in the movie *When a Stranger Calls* (1979), the accumulation of terror arises from the escalation of phone call threats, innocuous at first, that take on a whole level of added significance when it becomes apparent that the caller is already within the home. The idea of a threat existing already within the home disrupts any illusion that the home ever provided a secure space for establishing the structures of identity.

Another recurrent figure from genre cinema helps us understand both the structure and appeal of Derrida's thought. The renewed interest in zombies seen in films such as *28 Days Later* (2002) and *Resident Evil* (2002) reveals a fascination with the concept of the living dead. The living dead is a good example of a deconstructive entity. In breaking down the relation between the living and the dead, the zombie is an impossible creature, one ripe with visible embodiments of our projected fears. Often the living dead are a by-product of repressed colonial culture, representing an anxiety over repercussions from colonialism by the West. In the nineteenth century, vampires, such as Dracula, hailed from the East, representing another living dead parasite preying on the West. In more recent versions, the living dead are frequently a result of a technological mishap, science gone astray. Mary Shelley's *Frankenstein* (1818) serves as only the first of these fictive scientific monstrosities. New technology allows for Derridean creatures to come to life, revivifying the anxieties that former new technologies, like writing, once produced and destabilising traditional structural relations. Deconstruction can be envisioned, in other instances, through popular culture in the form of the body snatcher, a parasitical entity that takes over a host body. In movies such as *Invasion of the Body Snatchers* (1956) to *I Married a Monster from Outer Space* (1958), the thin line between the familiar and the unfamiliar is once again erased. Aliens, in these movies, pose as familiar individuals. Accepted at first as being who they appear, the alien presence is typically revealed through the absence of some trivial mark of individuality. Indeed, one of the things the alien parasite genre reveals is the way our identity is contingent on a few almost imperceptible quirks.

Needless to say, figuring deconstruction as a parasite offers ample opportunities for exploration. Still, it is worth noting that the paranormal opens up a space allowing us to think through some of the ways Derrida's thought may help us approach visual culture. In the paranormal, something exceeds the normal, going

beyond the limits of the normal. We, however, finally witness what defines normal experience within the paranormal. The desire fed by interest in the paranormal is a desire for something more. Religion is often fuelled by a similar desire. For a secular society, however, the paranormal offers a sign that the normal is not sufficient and in need of supplementation. It reveals the normal as not all that there is in existence. The paranormal points to something more. The world we normally experience as all there is is found lacking. Or, the world we experience is shown to always be prone to a radical disruption by the paranormal. In either case, our sense of the normal is always relational, always contingent on a series of interconnecting structures. For Derrida, the process of deconstruction is finding the point an entire structure depends upon and tagging it, leaving a mark indicating where the structure will come apart if you tug hard enough.

Chapter 7

Deconstruction's wake

Ruins are all around us, just waiting to happen. In taking apart the illusion of permanence attached to the transitory shelters that homes provide, the work of Whiteread and Matta-Clark evokes an element of the ruin, accentuating a slow process of decay marking all our structures as bound by time and place. Just as structures fix a particular space at a particular time, for instance the paintings of Jackson Pollock in New York during 1948, these structures in turn become subject to the effects of time or temporality. A structure both accrues meaning (as in the body of literature that interprets Pollock's work to films telling the story of Pollock's ascent) and begins to decay, marking the work's distance from its moment of inception. All our works are bound to become ruins. If there is a cryptic architecture to the structures pervading Derrida's writings, in part it has to do with the problems these structures pose.

A ruin is not a simple site. The ruin is a site from the past. Crumbling, it bears witness to the impermanence of all our structures. In its incompleteness, however, it also allows for a space of projection. Ruins in the early nineteenth century were associated with a Romantic mythology concerning a Self-seeking reunion with the past. The location of a ruin in the German countryside could serve as a mythic place structuring the identity of the Self, as in the work of Caspar David Friedrich. In unearthing the groundlessness of the Self, the ruin poses powerful questions relating to Derrida's thought and the visual arts.

The ruin appears in the text Derrida wrote for an exhibition he curated at the Louvre in 1990. The exhibition was the first in a series ('Parti pris' or 'Taking sides') structured around the concept of having a famous figure from another field work with the Louvre's archive of drawings. Derrida selected, for his exhibition, self-portraits and images pertaining to blindness. In subject matter, he juxtaposes a genre intimately connected to self-knowledge and self-revelation with visual images depicting the blind. The text Derrida created was stencilled onto the walls surrounding the works on paper included in the exhibition. As a result, *Mémoires d'aveugle: L'autoportrait et autres ruines (Memoirs of the Blind: The self-portrait and other ruines)* is both a book and an exhibition. Derrida once again exhibits an interest in hybrid constructions. The subsequent catalogue reproduces Derrida's text and many of the images from the exhibition.

Derrida, in the text, weaves together themes of memory, blindness, self-portraits, ruins and other fleeting figures of interest to visual artists. It could be suggested, in particular, that the book is about the hand and the eye, focusing on the fundamental experiences of the body and our attempts to represent ourselves. In focusing on touch and sight, Derrida is exploring two of the fundamental senses allowing us to access the world. Manipulating form in space through our touch and sight, we experience sensations that are re-presented by marks on a page or canvas. As an artist or writer, I have a thought, an image in mind, and then I proceed to use line either to form letters that become words that become sentences or to make hatch marks and lines suggesting an image. Derrida's interest in the experiences of the body, as mediated through hand and eye, is rooted, in part, within his explorations of phenomenology and the texts of Husserl, Heidegger and Maurice Merleau-Ponty, continuing an engagement that marks the earliest of Derrida's texts.

Touch or *tâche* is related to the visual concept of the artist's touch, as we have seen in relation to connoisseurship. Touch clearly

has a physical dimension. An artist's touch leaves a trace via the mark made on the canvas. The mark becomes a unit in a series of marks conveying an image to the viewer, who then constructs meaning out of this encounter by sifting the image through a repertoire of images and texts at his or her disposal. The mark may signify what the artist intended or it may signify something else, even something the artist may not have been aware of or that can ever be fully understood.

Blind soothsayers, prognosticators, poets and other intermediaries

In choosing to focus on images of blindness and self-portraits, Derrida is able to question the limit between the visible and the invisible. Offering another instance of the logic Derrida criticises, the relation between the visible and the invisible delimits what we think of in terms of visual art. Derrida, in the theme of blindness, is able to select figures from the oldest traditions in the West, drawing upon the Old Testament and mythology. Through Biblical figures such as the blind of Jehrico, Eli, Isaac and Tobit to mythological figures such as Oedipus and Tiresias, Derrida finds examples open to the effects of deconstruction.

For instance, several individuals able to prophesy the future, a specialised form of knowledge in the world of Classical antiquity, were depicted as blind. Not able to see the present, these figures saw the future. For a soothsayer, the idea of seeing into the future comes at the price of a blindness to the immediate world. The wisdom of insight comes from blind individuals whose own experience of gender, at times, complicates the stable oppositions we try to use to order our daily lives. Tiresias, for instance, experiences life as both a male and a female. Though blind, Tiresias could read the future and he could testify to the permeability of gender identity.

The fascination with blindness also relates to the work of Derrida's then deceased friend Paul de Man and his book *Blindness*

and Insight (1983). For de Man, the conceptual blind spots of a writer's text potentially hold its greatest insights. De Man's approach relates to Derrida's discussion of seemingly trivial moments within a text that destabilise its entire structure. Deconstruction, as presented by de Man, finds insight in an author's conceptual blind spots. These areas of blindness contain insights for the attentive reader that can undo the structural relations of a text.

Blindness also has an association with faith, one of the other subjects that Derrida raises in the midst of his textual polylogue – a form we've seen Derrida use before in his experimental work. A leap of faith suggests ignoring what our eyes allow us to see. For those in the Judeo-Christian tradition, even though one never sees God directly, one perceives His presence in the form of traces, 'the mysterious ways in which He works', events bearing witness to the divine. Of course, the act of bearing witness is always a leap, because it is done in the absence of that which one is affirming. For Derrida, however, blind faith is something demanded by more than just theological structures and institutions; it is also demanded by our cultural institutions and intellectual structures.

Regardless, blindness is not always represented as simply a lack of sight, as the prognosticators cited suggest. The blind have a power of vision in their literary and theological presentations. Interestingly, blindness is frequently associated with the literary arts. Through the semi-legendary figure of Homer, there is from the beginning a construction of the poet as an individual whose creative imagination is a result of lacking access to the immediate visual world. Lacking images, the poet creates verbal images from the sounds and descriptions of the visual events being portrayed. Such a mythology suggests that language is not as immediate as visual perception. At the same time, in being able to create images beyond what is simply observed in the present world, the blind writer can transport us to another time through her or his structures of fiction.

Derrida cites two other blind writers who are of importance in understanding another aspect of his development of deconstruction. The Argentinian writer Jorge Luis Borges (1899–1986) along with the Irish writer James Joyce are cited as two examples of writers who became blind. Both figures produced works addressing areas of language and representation pertinent to an understanding of Derrida's work. In the case of Borges, his short stories play with structures created by language and representation. His stories often reflect back on their own production, while crossing literary genres, combining elements of scholarly academism with surreal fantasy. Genre bending is something Derrida's own literary practice institutes by crossing between philosophy and literary criticism.

Joyce, in his world of linguistic constructions, tests the limits of language in representing the world. From the epically mundane events laid upon the loaded structures of Joyce's meticulous representation of the events comprising one day in the life of his protagonist (*Ulysses*, 1922) to the cacophonous Babel of *Finnegan's Wake* (1939), Joyce's texts go beyond simply being great works of modernist literature. They unearth some of the fundamental contradictions involved in the creative act – indeed, in any act of signification – making them of great interest to Derrida.

Visible blindness

Blindness complicates the simple opposition between vision and its absence. Derrida uses the theme of blindness as an opportunity to touch upon the work of the French existential phenomenologist Maurice Merleau-Ponty (1908–61). Merleau-Ponty's work explored the primordial structures through which humans experience the world. One way of thinking about this is by imagining a world of sensation without names, values and other associations to attach to perception. For Derrida, this represents another dream of purity. In the instance of vision, however, Merleau-Ponty, in a speculative

aside (the kind of aside that Derrida's work is built upon), suggests the existence of an invisibility at the heart of the visible.

Merleau-Ponty suggests a blind spot within the structure of the visible. Seeing is believing, but belief is a structure that blinds us even as it allows us to see. For instance, science provides a range of compelling structures supporting a theoretical representation of the world. Even in these systems, however, there are blind spots. Knowledge in fields as complex as string theory are structured around phenomena that cannot be seen. String theory, in its own way, provides a deconstruction of one of the most important tenets of science: physical observation. Rooted in a structured system of representation, where observation lends validity to a system, string theory suggests dimensions that can never truly be observed. Taken on a leap of faith, they involve a critical blindness. Likewise, quantum physics provides laws ordering the movement of very large objects that follow very consistent patterns, but cannot explain some of the foundational questions concerning the minutest building blocks of reality, such as the subatomic.

One of the writers Derrida considers in his discourse on the ruin is the German literary critic Walter Benjamin (1892–1940). Benjamin offered a view of the modern city in his various textual representations of Paris in the nineteenth century, Marseille on hash during the Nazi occupation, Moscow on the eve of Stalinism and the role of the ruin within German theatre of the Baroque era. Benjamin's use of the ruin offers one point of engagement for Derrida's open-ended polylogue. Benjamin's view of the world suggests that we exist in a complicated relation with both past and present, to put it mildly. The ruin, in one instance, can evoke monuments of bourgeois capitalism, such as malls. The ruination of the monuments of capitalism is envisioned in the midst of their triumph, as a necessary result of their construction. Benjamin's vision of ruins in the midst of modernity, a subject touched upon in many of the citations comprising his never completed *Arcades Project* (1927–40),

offers a way of understanding the time-bound nature of all our structures.

The temporal dimension of structures has always been a point of analysis for Derrida. He even reveals the beginning as a construction, a mythic origin delimiting our view from and of the beginning. For a strict Christian, the beginning of the world is covered in the Biblical tale of Genesis, potentially blinding the follower to any other possible narrative. For a scientist, the beginning of existence is defined by a scientific view, such as the Big Bang theory. In fact, some current research resists the idea of the universe's origin as a singularity, an idea that Derrida's work would seem to resonate with. Regardless, a narrative concerning the origin is constructed through texts prone to changing over time. Thus, Athenians of the fifth century represented the beginning of the world differently from scientists at the beginning of the twentieth century, and likewise for a Christian fundamentalist from the American South or an Islamic fundamentalist from the marginalised spaces of the Middle East. Each perspective depends on a different originary narrative.

What Derrida finds remarkable about these narratives of origination is how they come to determine a whole set of values for their adherents. These values come to form a structure of identity, but these structures of identity bear the strain marking the ways in which the structures that allow us to exist in society come to constrict our view of the world, blinding us to other possible structures. Derrida's work is attentive to these open-ended possibilities and he takes the ruin as a motif from Benjamin's work and transforms it into a figure for the self-portrait.

Derrida, in the process, once again undermines a mythic genre ordering a tradition of art within the West, namely, the self-portrait. *Memoirs of the Blind* is not the first time Derrida addresses issues relating to self-portraiture. In resisting traditional academic conventions, many of his texts blur the line

between the autobiographical and the academic. In the case of Derrida's essay for *Memoirs of the Blind*, not only does the text cross genres, but the text also exists in two places: first, on the wall of the exhibition, now inaccessible to viewers, and, second, in the book *Memoirs of the Blind*, now accessible in many languages. Of course, the text also appeared in other forms, too, such as Derrida's notes, the files on his computer and other intermediaries for the ideas he expresses.

Accessibility is intimately bound with the genre of the self-portrait. The self-portrait purportedly reveals the artist's 'soul'. Repeatedly, one hears reference to the self-portraits of Van Gogh and Rembrandt as revealing their individuality. In the early twentieth century the desire to attach an identity to portrait busts from antiquity led to the misattribution of names to portraits that may simply be generic, mass-produced works or to portraits whose identity will never be known – something befalling even the self-portrait, potentially.

Derrida utilises a great deal of autobiographical references in his text for *Memoirs of the Blind*, something that is more and more frequent in his experimental texts. In his account, Derrida discusses his own physical disability at that time, a temporary partial paralysis of the face. Leaving one of his eyes unblinking, he apes an identification with the longing figure of the monocular Cyclops, as seen in textual representations such as Homer's *Odyssey* or visual representations such as the symbolist Odilon Redon's (1840–1916) impotently desirous monster.

In discussing his own conflicted feelings regarding himself and breaking down the barrier between confession, autobiography, art criticism, philosophy and literary studies, Derrida relates tales that take his writing far beyond the realm of academic discourse. He relates a dream where he harboured murderous feelings for his brother. According to Derrida's reading of the dream, his jealousy emerged as a reaction to his brother's ability to draw, something the young Jackie admired.

In presenting the self-portrait as a ruin, Derrida acknowledges the indelible materiality of the mortal body, bound to decay. We may capture a momentary image, but this image is bound to slowly decay and disappear. Every representation we create and ascribe our identity to becomes a miniature tomb burying a Self. In considering Titus-Carmel's work in *The Truth in Painting*, Derrida latches onto the cartouche as a miniature tomb. While our work seems to stake a claim *for* our existence, it stakes a claim *to* our existence, coming to stand in for us, while also becoming a stake marking our passing. Seemingly intimate to our existence, the work displaces our identity through the Self that viewers construct out of reading the texts and images we create. Difference (or *différance*) marks these interpretations as transformations. The Self is far from timeless, and the self-portrait, a genre purportedly revealing *the* Self, reveals only *a* Self that no longer is. As potentially true for photography as it is for drawing, the self-portrait is marked by ruin from the start, because we, as mortal beings, are marked by ruin from the start.

In the origin of drawing, as it comes down to us in the West, a figure of loss describes the initial scene of artistic creation. In the tale of the Corinthian maid, a woman tries to capture an image of her lover, who is soon to depart for war. She traces by candlelight her lover's silhouette, capturing an image of her soon to be departed. The image comes to stand in for the one who is not there. The portrait, tied to a Self that one once was, takes on the form of a ruin. The ruinous structure of identity collapses in on itself. Lost in the rubble of the past, the self-portrait, simultaneously, conveys an element of presence as an object while implying the absence of the artist depicted. Combining elements of absence and presence, the self-portrait becomes a sign of ruin that Derrida ties to the mortality of the physical body and the transitory nature of all structures of Self.

We can think of the fragility of the Self in relation to Marc Quinn's self-portrait titled *Self* (1991). Quinn's work apes a tradition of death masks, but, instead of plaster, the medium becomes the artist's own frozen blood. The work's fragility requires

refrigeration to preserve the impression of Quinn's face, but even this technology does not ensure the work's endurance, as it will ultimately decay. The ultimate loss of this work is inscribed in its creation. Such impermanence reveals an important bridge between works of art and those of us who make and look at them. In our fragile mortal forms, as humans and the marks we make as artists, we utilise momentary structures through which we attempt to understand the world. All these structures are bound to fall, however, leading to the mournful undertone many of Derrida's texts possess.

In the blink of an eye

The self-portrait becomes a site/sight of mourning for something past. In its construction, the self-portrait reveals a point of blindness even in self-representation. In gazing into a mirror to depict the Self, there is a moment where the observing eye blinks. Derrida discusses the idea of the blink around the German term *Augenblick*, leading him back to the early terrain of his philosophical investigations, the work of Husserl. In looking at how Merleau-Ponty proposes an invisibility at the heart of vision, Derrida connects Husserl's *Augenblick* to Merleau-Ponty's blindness at the heart of sight. Blindness is also related to the moment an artist looks away from herself or himself in carrying out a self-portrait. In constructing a self-portrait, there is a moment when the artist turns from the mirror to the image. The artist, in this moment, must rely upon memory to recollect what he or she saw, a series of memories that become embodied through the self-portrait.

Even if an artist does not rely on a mirror in carrying out a self-portrait, there are moments when the artist blinks. The blink becomes emblematic of a blindness at the heart of all vision. There are moments where we do not see with our eyes, but with what we remember, our memories. In focusing on structural blind spots within the self-portrait and vision, Derrida points to the role of

memory within all our acts of perception. The gap in the structure of looking delineating the self-portrait opens up a space of memory. While the gap, represented by the blink or turn of the head, seems to be a trivial limit case, again, for Derrida, this limit case becomes indicative of a structural blind spot where the normal 'either/or' structures of how we think give way to a more complicated, if at times contradictory, way of accessing the world. Vision becomes intimately related to memory, and memory becomes an integral force in defining who we are as subjects.

If vision is not just about what we see, but what we imagine we see, memory is not just about what happened, but how we remember what happened. Never a simple objective procedure, for Derrida, it is one demarcated by a logic of 'both/and'. A memory is something both in the present and in the past. As the ruin is something existing in the present, but in a decayed form from a purportedly fuller past, a memory represents something from the past, but at a distance from the past as it is experienced within the present.

In this way, memory and ruins offer important connections to ideas pervading Derrida's thought. In part, this relates to Derrida's questioning of the purity and wholeness of the origin. If both memory and the ruin point to something from the past that is imagined as once whole, Derrida wants to suggest that the ruin is already a possibility within the past, just as a memory is already a possibility within the past. The completeness of a structure exists only in relation to its ruination, just as the past exists through the proxy of a memory. For Derrida, the origin is an invention within the present of a supposedly whole past. Mythologising a lost pure origin is something present at the heart of the myth concerning the origin of drawing. In trying to preserve an image of the origin as pure and whole, an image of origin is constructed. For Derrida, however, this origin only ever exists as an image. There is no pure origin, according to Derrida, just as there is no pure vision. No vision, without blindness

already in tow. No structure without its potential for ruin. No origin without supplementation.

Re-membering the contemporary

The blink opens up a space of blindness within the structure of the self-portrait. Moreover, the blink creates a space where memory comes to fill in the gap. Memory also relates to a process of mourning. Derrida considers the act of mourning in several texts, putting his work into a dialogue with the psychoanalytic thinking of Freud. Mourning provides another instance where the structures purportedly defining who we are as individuals begin to shake. In particular, the barrier between Self and Other is challenged in the process of mourning. In mourning, a piece of the Other is internalised. We take on an expression, a gesture or a habit producing a connection to a lost Other. In doing so, we preserve a part of the Other at the core of our identity. The identity of a Self becomes mediated through an intense identification with a lost Other. Mourning also subverts the limit between absence and presence. In mourning, we experience a presence through an absence. Someone departed is made present momentarily through memory and memorial. Themes of memory, mourning and memorial mark not only Derrida's *Memoirs of the Blind*, but also his texts written after the death of some of his closest colleagues, including de Man, Emmanuel Levinas (1906–95) and Barthes (*The Work of Mourning*, trans. Pascale-Anne Brault and Michael Naas, Chicago: University of Chicago Press, 2003).

Memory and mourning are powerful themes within both contemporary art and art's relation to history. In the work of Rachel Whiteread, we saw how memory was a theme opened up by her site-specific work *House*. In her *Vienna Judenplatz Holocaust Memorial* (1997), Whiteread expands upon her poetics of memory to engage cultural memory within a space beyond her native England. Located in Vienna, Austria, Whiteread's memorial occupies one of the central downtown public spaces. Her memorial takes

the form of the cast space of a private library, typical of established Jewish families in pre-World War II Vienna. With the occupation by Nazi Germany, many of these libraries were destroyed and their books burned, resulting in a traumatic loss for those families who managed to escape the horrors of the extermination camps. As a memorial to the unimaginable, the Holocaust, Whiteread tries to create a space allowing both for the personal space of memory for Jewish families directly affected by the Holocaust, and also a larger space of cultural memory for a public marked by the history of the Holocaust. The ghost-like evocation of Whiteread's sculpture allows for a space where both private and public memory can be addressed.

As in *House*, a public site becomes one of memory by making physical the structures that have been torn away. In the case of *House*, the absent presence of a row home conjures up traumatic memories on a cultural and a personal scale, simultaneously for some viewers. In the *Holocaust Memorial*, a private library opens up discussion not only of cultural memory and personal loss, but also of restitution. The question of restitution is central to Derrida's exploration of the confrontation between Schapiro and Heidegger in 'Restitutions of the Truth in Pointing'. There too a question of how to remember the Holocaust arises. For Derrida, there is no end to representing the Holocaust, but Derrida argues elsewhere that there should be no singular proper name ascribed to the Holocaust. Derrida cites a potential problem of forgetfulness even in remembering the Holocaust by ascribing a single proper name, such as 'Auschwitz', to the tragedy. In privileging Auschwitz, we risk forgetting all the other sites of horror pertaining to the Jewish Holocaust, such as Bergen-Belsen, Buchenwald, Dachau and Ravensbrück, and we also risk forgetting other examples of genocide globally, from the killing fields of Cambodia to the Armenian genocide, while potentially remaining blind even to contemporary acts of genocide, as in Sudan and Rwanda.

In constructing the *Holocaust Memorial*, Whiteread had to recreate a lost original. If, in *House*, she could cast the interior of the building being torn down, retaining some of the particularity of place through the physical *trait* or trace of the lost structure, in *Holocaust Memorial* Whiteread already has to work around a structure of loss. To create the interior of the library, she fabricated forms for the shelves of books comprising the main element of the work's surface, being broken only by the impression of double doors. The control over the forms provides a strong uniformity to the monument and allows the structure to open up to other architectural associations. Her work takes on a regularity associated with neoclassicism, an architectural form used to ape monumentality during the Nazi era in Germany. Such architectural allusions are associated with the challenging process of trying to remember the history of Nazi Germany. Artists such as Anselm Kiefer make allusions to the architecture of Nazi Germany in order to work through questions of German identity. Indeed, Whiteread's form seems to allude to the architectural form seen in Kiefer's *To the Unknown Painter* (1983).

In Whiteread's case, however, the form of the sculpture augments a dialogue concerning space that her work's proximity to architecture raises. Whiteread's work is not simply an object to be housed in a building. It is the interior space of a building made solid, allowing us to see the way space is defined by architecture. The allusiveness of Whiteread's form, simultaneously mausoleum, monument, charnel house, prison and, simply, a library, offers a space for thinking through what it means to think the memory of the Holocaust. She does this by focusing on just one space from one room, presenting the Jewish people not simply as a people of the Book, but of many books, a people of culture living within a world, hopefully, built from diversity, trying to remember the extraordinary adversity inflicted upon the Jewish population at a time when a constructed myth of racial superiority perpetuated some of the worst horrors in human history.

Whiteread's work also engages two sites. An adjacent museum provides for education concerning the history of Jews in Austria, functioning in a fashion similar to the *Jewish Museum* designed by Daniel Libeskind. The question of anti-Semitism is a constant point of dialogue for Derrida's work. In particular, Derrida provides several powerful commentaries on the work of the Jewish poet Paul Celan (1920–70), who survived a concentration camp to write poetry. The work of Celan was the exception to Theodor Adorno's stipulation concerning the limits to poetry after Auschwitz, articulated in the German philosopher's oft-cited essay 'Art after Auschwitz'. (In 2001 Derrida was the recipient of the Adorno Prize in philosophy.) For Derrida (*Feu la cendre*, Paris: Editions des femmes, 1987 – *Cinders*, trans. Ned Lukacher, Lincoln: University of Nebraska Press, 1991), Celan provides another layer to the concept of the *trait* or trace. In the poetry of Celan, the *trait* or trace becomes associated with his use of the word 'cinder'. Evoking the inferno of mass extermination, the cinder provides another material instantiation of the trace that bears witness to human existence. As a mark, it becomes a visual embodiment of Derrida's thought.

Visually, through contemporary art, we can think further about Derrida's association of the *trait* or trace to other words, such as 'cinder' or 'ash', that are associated with cultural loss on a personal level. For instance, the work of Ana Mendieta offers a take on the trace from recent art. A Cuban expatriate, she explored pre-Columbian myths concerning Cuban culture in many of her pieces. Documented through photographs, her works comprised bodily impressions made in the earth. Within these female forms, moss, fire, blood and other evocations of primordial creativity were present.

Phallogocentrism

In evoking the female form, Mendieta also offers counterexamples to the ideals of European patriarchal society. Derrida offers a

critique of patriarchal society through his deconstruction of the values associated with such systems. In his texts, he parodies the symbols of patriarchal society through evocative puns mocking the ideal of male virility pervading Western thought. Derrida uses the term 'phallo-logo-centrism' to offer a critique of patriarchal society. At times, he adds to the base term 'phallogocentrism', leading to even grander and more beautifully absurd neologisms or sayings, such as 'carno-phallogocentrism' and 'phono-phallogocentrism'. For Derrida, the word 'phallogocentrism' criticises two aspects dominant in Western cultural traditions.

First, Derrida, through the term, exacts not only a criticism of male dominance within Western society, but also suggests this dominance is supported by the values instituted and articulated through Western philosophy. Within the Western tradition of thought, Derrida frequently demonstrates how positive values are ascribed to male identity, while negative values are often associated with feminine identity. The question, for Derrida, of how to take apart a patriarchal system is not simply a matter of reversing the system's values and replacing it with a matriarchal society, but to challenge the very hierarchical structures we already impose on the world through the ways we think. One of the more interesting engagements concerning the relation between deconstruction and feminism takes place in Derrida's round-table interview with Christie McDonald (*L'oreille de l'autre*, Montreal: Vlb Editeur, 1982 – *Ear of the Other*, ed. Christie McDonald, trans. Peggy Kamuf, Lincoln: University of Nebraska Press, 1985).

In addition, Derrida's essay in the book ('Otobiographies: The teaching of Nietzsche and the politics of the proper name') offers a consideration of the misappropriation of Nietzsche's thought by the Nazi regime. Derrida suggests such misappropriation is possible not only with Nietzsche's thought, but, potentially, with any individual's thought, including Derrida's. It is not enough simply to say that a misappropriation is an incorrect interpretation of a text or work of art. For Derrida, denying an interpretation

simply as a misappropriation fails to confront the reasons why such a misappropriation was possible in the first place. The possibility of misappropriation is inscribed in the very possibility of appropriation. A correct interpretation implies a misinterpretation. An artist or writer has no ultimate control over the ways her or his work will be read, quoted, cited or used by future generations. Or others.

In the interview with McDonald ('Choreographies'), the idea that there is no singular feminism emerges. For Derrida, there is already a delimitation of feminism by trying to give it a singular image, as in the term 'feminism'. Instead of one brand of feminism, there should be several brands of feminism. Our attachment to singular identities, such as feminism, relates to the media-saturated world of the early twenty-first century. Popular culture provides brands through the mediated images pervading the daily visual consumption of average spectators. The term 'feminist' may invoke a constructed image of what a feminist is, leading to the construction of a monolithic stereotype. Derrida seeks a form of thought not built around such simple stereotypes. In advertisements from the late twentieth and early twenty-first centuries, a well-documented backlash against feminism took place. In ads for SUVs, soccer moms in America and football mums in England were presented as quasi-feminists to counter a constructed stereotype of aggressive feminists from previous decades. Such ad campaigns targeted consumer culture, constructing an identity to be emulated through an act of capitalist consumption, one purchase at a time. We can say that this is a misappropriation of the term 'feminism', but, if we are to think critically, for Derrida, we need to ask why such an image of a 'quasi'-feminist is possible. In part, it is both a structural possibility, as a woman who owns an SUV could be a feminist, but it also has to do with the role the popular media plays in providing prefabricated structures for our identities.

Branded by the logos we wear and bear, we capitulate to choices delimited by the range of visual images we choose on a daily basis. In not thinking through the implications of these choices, we not only brand ourselves with corporate logos as forms of parasitical identity acquired in the pursuit of material goods of status, we also brush up against the second part of Derrida's term, phallogocentrism. If *phallo* invokes the phallus as a symbol, suggesting the male-centric tradition of Western thought, *logos* invokes the centrality of the word made flesh, the Judeo-Christian God (*Logos*), and the Greek word *logos*, meaning 'word'. Again, the centrality of logos to the Western tradition suggests not only how values are constructed through words, but also how these values are intimately tied to the theological traditions of the West. Through phallogocentrism, Derrida both criticises and celebrates the centrality of language within the Western tradition and critiques the privileging of the spoken word over the written word or painted image (as when Derrida uses the term 'phonophallogocentrism'). He also criticises the theological dimension to this tradition in the idea of the *Logos*, the word made flesh. Against the name of the Father, Derrida takes apart the core structures to Western identity in both its theological and domestic guises, even as he explores Biblical and mythological tradition in his own textual constructions. For instance, Derrida examines the theme of blindness through Biblical and mythological figures in *Memoirs of the Blind*.

In this text, tears are a central facet to Derrida's consideration of vision. If there is a blindness at the heart of vision, at times, our eyes are blinded by tears. Tears offer a *trait* of differentiation from animals. The human eye sheds tears, while the eyes of animals only have tear ducts. The word 'tears' (*larmes* in French) bears a productive ambiguity in its visual form, which can be read either as a 'tear', a drop of salty water from our tear duct, or as a 'tear', as a rip in a piece of clothing. Tears are often associated with moments when we are feeling torn, or, for Oedipus, when he

tears his eyes out, blinding himself to the tearful reality of having transgressed the prohibition against incest. Tears are, however, like all good visual figures of deconstruction, more than a singular image. Besides tears of anguish, there are tears of joy, tears associated with grief, tears of laughter and tears associated with the mourning process.

Against the monumental

Mourning takes on another powerful visual form in the work of Thomas Hirschhorn, which allows for a dialogue between contemporary art and the texts of Derrida. In *Raymond Carver Altar*, Hirschhorn takes apart some of the oppositions ordering the tradition of the monument. Formed in the fashion of a spontaneous sidewalk memorial, Hirschhorn's monument replicates the appearance of personal memorials that frequently line sites dedicated to remembering someone who has died tragically. Often associated with highway accidents or celebrity deaths, such as Princess Diana and JFK Jr, these sites are comprised of notes of condolence, candles, flowers, cardboard signs and stuffed animals bought from a dollar store. Hirschhorn, in his work, uses all these items, adding to them books by the American writer Raymond Carver. Hirschhorn has done similar anti-monuments to other cultural figures, such as the de Stijl painter Piet Mondrian (1872–1944) and the philosopher of the schizoid subject and contemporary of Derrida, Gilles Deleuze (1925–95).

First executed in Fribourg (1998) and then in Philadelphia (2000), Hirschhorn's work takes over a public space, resulting in a gathering of urban viewers. Some may be familiar with the work of Carver (1938–88), or even the work of Hirschhorn. Still, others stop and try to speculate as to why the monument is there before them. In the case of Philadelphia, I even heard a conversation attempting to identify Carver as someone who was shot near the location a few weeks earlier. In constructing a link between a spontaneous memorial, or, rather, a work of site-specific

installation art mimicking the appearance of one of these populist public memorials, Hirschhorn activates a space where memories, imagined and real, conflict and confront a work that challenges its relation to the institutions of art. Existing beyond the defined walls of the gallery, Hirschhorn uses non-traditional materials exposed to the elements. The only objects he makes are the meagre signs and constructions paying homage to Hirschhorn's love of Raymond Carver and his work. In choosing Carver, Hirschhorn selected a writer whose own work involved the representation of everyday individuals confronting very traumatic, but human, situations. The commonness of Carver's language finds a parallel in the commonness of Hirschhorn's materials, working against a tradition of triumphal memorials. The memory of violence, imagined or real, associated with the site by some spectators happens to resonate with the sometimes violent worlds Carver depicts.

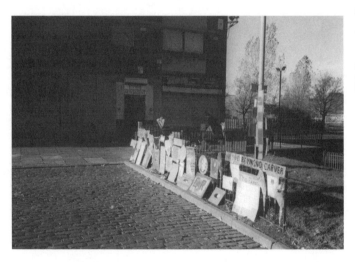

2. Thomas Hirschhorn,
Raymond Carver Altar
(1998/2000), Glasgow.

Exposed to the public, Hirschhorn takes his work out to the public, but surreptitiously. Hirschhorn, in doing this, offers a powerful opportunity for thinking about the role of public memorials. In contemporary cities, monuments to the memory of people often centuries dead delineate major urban thoroughfares and are passed daily by thousands of viewers. Hirschhorn, in his temporary work and impoverished materials, manages to stop viewers and make them aware of Raymond Carver. In the end, it does not matter so much whether someone remembers the writer who died nearly twenty years ago or imagines the loss of some anonymous passer-by at the work's temporary location. In stopping a viewer, Hirschhorn's work opens up a space for contemplation in the midst of what normally is a nondescript site. In activating a space for reflection, Hirschhorn presents a theatrical stage for mourning, leading us into a consideration of the internal theatre

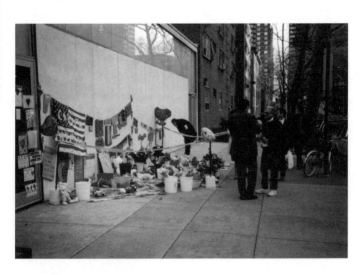

3. Thomas Hirschhorn,
Raymond Carver Altar
(1998/2000), Philadelphia.

of identity staged by mourning and raising questions concerning the popularity of these public memorials. Derrida regularly contemplated mourning not only in his larger body of work, but especially within the context of his consideration of visual art. As a result, Derrida suggests that the visual plays a powerful role within all our acts of memory. When we consider memory, we can conjure up an array of physical objects serving as a trigger for memory. From Marcel Proust's madeleine to the photographs and *tchotchkes* we fill our interior spaces with, the visual plays a key role in providing a physical trace of the past. Any object has the potential to bear that physical trace, if our vision associates the object in question with some absent Other.

Chapter 8

Going postal: postcards and other identifying documents

The postcard negotiates the space between Self and Other in ways lending themselves to deconstructive analysis. Derrida (in *Le carte postale: De Socrate à Freud et au-delà*, Paris: Flammarion, 1980 – *The Post Card: From Socrates to Freud and beyond*, trans. Alan Bass, Chicago: University of Chicago Press, 1987) uses the structure of the postcard to question all forms of communication, while, simultaneously, challenging the fundamental values of both psychoanalysis and philosophy. The first essay in Derrida's book, 'Envois', is comprised of 254 pages of transcribed passages from postcards supposedly sent between 3 June 1977 and 30 August 1979. The fictive missives are all posted on multiples of the same card, a print by the thirteenth-century Benedictine monk Matthew of Paris depicting Plato dictating to Socrates, who is shown writing. The irony, for Derrida, is that Socrates supposedly did not write, but was written about by his students, such as Plato. While this may have been a mistake on the part of Matthew of Paris, Derrida sees in this chance error an opportunity to discuss the potential errors inherent in any relay of messages.

Written as a series of love letters (*philosophy* is, literally, a love of knowledge), only Derrida's portion of the exchange survives. The cards sent to Derrida by the Other, who is never named, no longer exist. In the midst of the dated entries, the reader learns that a portion of the exchange has reportedly been destroyed, although the reader never discovers why. As with other examples of Derrida's experimental style, the literary form of *The Post*

Card is critical to understanding the problems concerning communication being presented. Any act of communication at a distance runs through relays, from the beginning of civilisation to today. Moreover, our knowledge of the past depends on the relaying of information from one era to another. History depends on the relay of documents. In the West, civilisation is defined by cultures that leave behind written documents, something defining them as already cultures of the archive and writing.

Over the course of Derrida's missives, numerous instances of miscommunication performed in the fragmented texts suggest the delay and decay inherent to all documents. Pieces of text are missing. While frustrating any reader seeking a singular point to his literary performance, Derrida's puns, prosaic style and fragmented approach accrue meaning, making his text a pleasure to read. His text is demonstrating the problems any act of communication is subject to, one that is condensed in this instance by referencing the form of the postcard. The postcard only helps to accentuate these difficulties, while also leading to other phenomena fuelling Derrida's analysis.

For instance, the postcard is a form of communication that is simultaneously public and private. Personal messages are written on a card with an image on one side and sent through the post. The writing on the card, which may be personal, is visible to all along the way. For Derrida, however, it reveals how all acts of communication have a potential for becoming public acts, whether they are public or private. For people in positions of authority, something said in private may potentially become public knowledge. Likewise, the private letters and diaries of an artist or writer may eventually become public. Derrida refers to the scandal that the revelation of the correspondence he is writing will cause.

Moreover, Derrida's text is not necessarily the truth. Even in his quasi-confessional mode, filled with autobiographical allusions to actual events, Derrida's writing hinges on the fact that it is

writing and is subject to the pitfalls of any written or spoken word and the limits of communication. Derrida's analysis of communication also raises questions concerning the limits to psychoanalytic and philosophical discourse ever fully revealing the truth. The conveyance of truth is always contingent and tied to a whole set of frames that come to construct the subject according to culture, class, gender and so forth at a particular time and place. In resisting simply a philosophical tone, Derrida is able to play up allusions to Heidegger, Lacan, Freud, Socrates, Plato, Nietzsche and others, while writing some of the funniest and crudest text of his career. He also embeds a brief history of the postal system and offers a rumination on the dead letter office.

The essays in *The Post Card* create a set of interconnections between one another via the interrelations between the structural concepts being taken apart. Such allusions across texts mark a similarity to the structure of the essays in *The Truth in Painting*. While independent of one another, all the essays allude to one another, exploring a set of interrelated structures concerning a particular concept. As in *The Truth in Painting*, one of the constructions within Western tradition that Derrida is questioning through these essays is the concept of truth. In constructing the truth, thinkers have recourse to constructing a system to prove a truth. The problem is, they construct a truth that fits within their system, and they construct this truth before the system. For instance, if you wanted to construct the number 4, you can produce any series of equations to arrive at this answer: 5–1, 3+1, 4x1, 16/4, 454–678+232–4 and so forth. In the case of psychoanalysis, there is an assumption that a truth awaits unearthing through the discourse of the patient. The analyst waits to discover what is significant within the messages of the analysand, the one being analysed. In part, Derrida's criticism of the phallogocentric nature of psychoanalytic discourse resides in its dependence on an ultimate authority figure, one who knows. Verifiable truths are quite meagre, according to Derrida. The truth is not so much an

impossibility but, rather, necessarily bound to a recognition of the mortal limits to our temporary concepts of truth. The truth cannot exist independent of the structure that constructs it. The discourse of Lacan, Heidegger, Freud and, by implication, Derrida produces a 'truth', but a truth that is always dependent on its production through the text the reader is reading.

The philosophical limits of verifiable truth offer some guidelines to understanding the art of On Kawara. Kawara, in his own series of postcards, offers not a rich, open-ended discourse on the speculative nature of every attempt to render the truth, but a simple repetition of the statement 'I got up at' followed by the time. Testifying to the moment Kawara became conscious, his series of postcards were sent daily from 1968 to 17 September 1979. The series came to an unintended end when Kawara's briefcase, replete with postcards and rubber stamps to print his statement, was stolen in Stockholm. The individual postcards always bore an image of the city from where Kawara was sending them. Kawara's postcards bear on one side his impersonal rubber stamped statement 'I got up at X' and the regional stamp of the postal service, a mark of authenticity testifying to the date the postcard was sent.

Kawara's work involves a series of projects documenting his existence. Besides the postcards, he sends telegrams testifying to his continued existence ('I am still alive'), keeps typed lists of the people he saw ('I met'), records of the routes he takes and the doors he enters, and continues to produce date paintings whose existence is contingent on being completed on the date that is meticulously painted by hand on his monochromatic canvases. Necessitating upwards of twelve hours to complete, Kawara destroys any painting failing to meet his self-imposed deadline. Stored in customised boxes, newspaper clippings and other documents testify to their day of execution. The date is written in the dominant language of the city he happens to be living in on that date. All these works offer information about Kawara, but nowhere do we get an idea of Kawara's emotions, undoing a tradition of Romantic self-expression.

Kawara's work provides only the most scientifically verifiable information concerning his Self. The Self is a construct within the visual arts that reached its apotheosis in the modern age. The idea of an artist being connected to the work of art in an intimate way helped to construct a quasi-theological aura over the works of early modernism. For instance, the works of Van Gogh become quasi-relics of an artist whose mythology far outweighs the ample discussion of what can be suggested about Van Gogh through documentation. Within all of Kawara's work, we gain no idea of his mood, his thoughts and his politics. Instead, we know he exists and is committed to a project that is both conceptual and material. His renunciation of expression leads to work dependent on a series of *parergonal* structures, including dates, postcards and stamps. Kawara's simplicity in form and concept nonetheless poses difficult challenges, because it reveals how much we project onto works of art. The artist, in the West, is invested with quasi-theological powers, an ability to communicate what cannot be communicated in any other way. Or so the idealist tradition of Kant suggests. In Derrida and Kawara, there is a challenge to the purpose of written discourse and visual art. If Derrida questions the structures organising the postal system, and through his analysis the structures of some of the most important thinkers of the Western tradition, Kawara brings a minimalist approach to conceptual art, reflecting a background in both Buddhism and also the post-World War II Japanese avant-garde.

Shit matters

Additionally, Derrida's thought can be related to several contemporary artists whose work combines a conceptual dimension with a critique of fundamental ideas within the Western tradition. Wim Delvoye, for one, challenges the constructed nature of human values relating to art through his artistic interventions within the market of art. Most infamously in *Cloaca* (2000), Delvoye raises questions concerning the values we ascribe to art, the human body,

technology, science and faeces. Through a series of vats, tubes and chemicals, Delvoye had scientists craft machinery replicating the various stages involved in human digestion. With a blender serving as a mouth, *Cloaca* was fed twice daily, typically from a fine restaurant representing the local cuisine of whatever city the work was being exhibited. The result of the blending and 'digesting' of the foods leads to the production of turds, which the artist then sells to pay for the costs of the technology.

Seemingly a radical approach to making art, Delvoye is picking up on a long tradition of utilising faeces to test the art market, as in Piero Manzoni's *Merda d'artista* (1961). Here, Manzoni canned his excrement, selling it by weight at the price of gold and making literal the alchemical idea of turning shit into gold. Sold at the price of gold, Manzoni's work, like Delvoye's, exposes the ability of the art market to generate value independent of any rationale. The human fascination with the scatological runs deep, from Classical antiquity to the Middle Ages and beyond, to Duchamp's *Chocolate Grinder No. 2* (1914) and all of *Cloaca*'s other artistic forebears. Scatological humour, for some, also entails a human fear of waste. The suppression of waste in Western culture ultimately leads to the return of the repressed in the form of environmental crisis in the twenty-first century. Delvoye's work can be read not only as concerning human reactions to excrement, but also human relations to the body in an age of technology. If we can understand waste as a natural by-product of a series of chemical processes, why do our reactions to shit go beyond the rational? This question drives some of the speculative dimensions of psychoanalysis, especially in the foundational work of Freud. Freudian concepts were appropriated by surrealist artists to push scatological buttons within the human psyche. Among the surrealists was Jacques Lacan, who also leaves behind faecal traces in his body of work.

At the same time, Delvoye's work questions how we define the human within a technological age. While computer research uses technology to create artificial intelligence, Delvoye uses technology

4. Wim Delvoye, *Cloaca – New and Improved* (2001).

to produce artificial faeces. *Cloaca* seems both to parody and embrace a culture of spectacle, where the transgressive force of art retains a power to stir debates concerning the categories defining us as human. At the same time, Delvoye produces a work whose performance suggests something absurd about all human technologies. In taking ideas to their limits, the experimental work of artists as different as Kawara and Delvoye opens up possible resonances with the experimental texts of Derrida.

In relation to *Cloaca*, Derrida frequently engages in the scatological, especially in his most experimental work (*Glas* Paris: Galilée, 1974 – *Glas*, trans. John P. Leavey, Jr., and Richard Rand, Lincoln: University of Nebraska Press, 1986). The scatological offers merely one among many bodily fluids appearing in *Glas*. There are also allusions to spit, semen, blood and pus, to name a few additional traces of the material body appearing in Derrida's juxtaposition of the German philosopher Hegel (1770–1831) with the French outlaw homosexual writer Jean Genet (1910–86). Bodily fluids differentiate the human body from the artificial body of prosthetics. They are material traces bearing witness to the mortality of the body. Again, in these physical remainders, such as waste, there are visible signs of existence, a physical trace that science can use to discern a wealth of information, as field archaeologists can testify. In the visual archaeology of Derrida, bodily disjecta come to indicate areas where the underlying values of society are grounded. Bodily fluids emit from sites that are thresholds where the relation between inside and outside breaks down, resisting the traditional categories ordering Western metaphysical discourse. Delvoye creates something that resists the categories through which humans have become accustomed to organising the world. Derrida's task as a thinker is to shake the foundations of our house of intellectual cards, revealing moments where two sides of the same card meet, at its edge or margin.

Chapter 9

Rites of looking

In 1985 Derrida wrote a text (*Droit de regards*; *Right of Inspection*) to accompany a photo-novel by the Belgian photographer Marie-Françoise Plissart. Plissart's photographs comprise a hundred-image photo-novel. In the course of these images, several familiar themes appear from Derrida's texts: the frame, genre (and gender) bending, mirrors, traces and memory. The work is presented as a visual loop, providing a series of interconnecting narratives that the myriad voices of Derrida's polylogue address. As in his other texts on the visual arts, Derrida both attends to the specific visual work providing the occasion for his essay, while also moving beyond the specific work to address larger issues relating to the visual.

The frame serves as a bridge between *The Truth in Painting*, *Memoirs of the Blind* and *Right of Inspection*. The concept is present in some form within all three texts. In *Right of Inspection*, it is the ever-present play of frames in Plissart's photographs that marks the most graphic element susceptible to Derrida's parasitical workings. The frame, in Plissart's work, often appears in relation to pictures within pictures. Often these pictures within pictures frame a narrative that is simultaneously past, present and future. The temporal complexity of Plissart's use of framed photographs offers one visual example of her play with the frame. Another exists in the layout of the photographs in her photo-novel. Sometimes, whole figures are fragmented by the framing of the page layout. A complete figure is comprised of two juxtaposed images within a page's layout. The layout of images

has many connections to the narrative aspects of the most sophisticated comic book art, as in the case of Dave Gibbons.

Like the graphic novel, Plissart's photo-novel blurs the line between mediums, making a visual medium. Moreover, Plissart's work is graphic on several different levels. The images are strikingly composed, alluding to many different photographic traditions, ranging from fine art, erotica and advertising. Derrida's texts affirm genre crossing as a potential means of activating the effects of deconstruction. Such crossing of genres or types of literature is a common feature to contemporary literature, one of the many fields to which Derrida's thought has been disseminated. The French word *genre* also evokes gender, another area where there is a moment of conjunction between Plissart's photographs and Derrida's texts.

In French, the title of Derrida's essay (*Droit de regards*) can be read on many different levels. The phrase can simultaneously suggest 'the right to the gaze', 'the law(s) of looking', 'the right to supervision (or surveillance)', 'the laws of supervision' and, lastly, 'right of inspection'. Derrida's choice of the term *droit* also relates to questions he addresses regarding the relation between the law and justice ('Force of Law: The "mystical foundation of authority"', trans. Mary Quaintance, in Drucilla Cornell, Michel Rosenfeld and David Gray Carlson eds, *Deconstruction and the Possibility of Justice*, New York: Routledge, 1992). Derrida, through the term *droit* ('law') carves out a space to take apart structures, such as justice, that are integral to the law. Utilising the polylogue once again, Derrida broaches several issues concerning Plissart's work that his title *Droit de regards* raises, while also opening up potential connections to several contemporary photographers.

Fake can be just as good

The work of Jeff Wall offers several mutual meeting points with the texts of Derrida. The Canadian photographer considers the role of appropriation as a conceptual device, exercising his right to

appropriate purposefully. He frequently finds visual equivalents between the contemporary world and images from art history. Composing imagery seemingly culled from the everyday world, Wall constructs works, such as *Mimic* (1982) and *People on an Overpass* (2001), bearing allusions to famous paintings by late nineteenth-century French artists. In part, these images are inspired by the influential art historian T. J. Clark. Clark's *The Painting of Modern Life* (1984) framed the social context for these Parisian paintings. In doing so, Clark cites Meyer Schapiro's previous assessment of this age, in which art was reframed by turning its attention to scenes of spontaneous sociability in the urban modern world.

Wall's translation of Clark's source imagery leads to new connections between the late nineteenth-century *banlieue* ('edge') of Paris and the late twentieth-century netherworld between urban centre and suburban idyll. Wall, like Clark's Parisian painters, represents spaces resisting the simple opposition between suburb and urban centre. These forgotten spaces mark a territory marginalised in traditional visual imagery. Wall, in focusing on these under-represented spaces, questions the investment we as viewers have in reassuring categories, such as city, suburb and country.

The relation of photographic image to reality is another pairing of categories Wall's photographs take apart. At times, viewers may be momentarily fooled concerning the veracity of even Wall's most violent images, such as *Dead Troops Talk (A vision after an ambush of a Red Army patrol, near Moqor, Afghanistan, winter 1986)* (1991–2). The version in the Philadelphia Museum of Art often yields the question of whether it is real or manipulated, reflecting a culture where our relation to photography is more complicated than ever.

Wall, in other works, sets conceptual limits to construct his work. In *Fieldwork* (2003), Wall observed a group of anthropologists voyeuristically waiting for a moment to photograph. Given his

propensity to stage photographs, even images not digitally manipulated lead to questioning of their authenticity, suggesting the limits to a documentary tradition relying purely on the photograph in an age of digital manipulation. Nevertheless, if these photographs are not manipulated, they are already framed by Wall's own conceptual guidelines delineating this particular visual project. Wall's work reveals no universal truth in photography, except a truth constructed through how a photograph is framed.

Stan Douglas is another Canadian photographer whose work explores the conceptual possibilities of photography in the early twenty-first century. In works such as *Contemporary Set for Sandman* (1995) and *Every Building on 100 West Hastings* (2001), Douglas constructs images blurring the lines between mediums. In *Contemporary Set for Sandman*, there is a seemingly direct representation of a movie set. The movie set is actually an installation constructed for the photograph, however. Douglas' work overtly acknowledges the way his photographic frame comes to stage the scene we as a viewer experience. Gillian Wearing, who we looked at earlier, is another contemporary photographer whose work raises issues concerning the truth value of mediated images. A decision process, whether by an institution, viewer or photographer, structures an aspect to the *droit de regards* (right of inspection), framing our relation to photographic images. As artists, Wearing, Wall and Douglas willingly construct the conceptual parameters to the world they are framing in their individual works of art. In each case, the artist makes a decision that destabilises one of the key oppositions normally ordering the way we approach the visual.

If Douglas' work evokes a film set, the photographic series *The Valley* (1998–2003) by Larry Sultan documents the sets of adult films in California's San Fernando Valley. The suburbs of the San Fernando Valley represent idyllic aspects to the American dream, while simultaneously possessing the dubious distinction of being the capital for America's adult film industry. Sultan discovered

while on assignment for a magazine that the homes used in many adult films were rented from residents of the valley, providing a lucrative side income for those climbing the socio-economic ladder. Homes belonging to doctors and lawyers, the very fictionalised heroes of American television, become a site for the number-one-grossing entertainment industry in the States.

For Sultan, who grew up in the San Fernando Valley, this discovery took on a personal dimension, as some of the homes he was being taken to were in neighbourhoods he had known as a child. Sultan, in the resulting photographs, focuses on areas just beyond the frame of the movie being filmed. A group sex scene may be blocked by a hedge, allowing the viewer's attention to explore the lush backyards and luxury homes serving as the sites for this activity. In interior shots, a limb may enter what seems at first to be a photograph of an opulent living room. Within the spaces of American domesticity, the marginalised activities of the adult film industry take place. The conjunction of pornography and the domestic spaces of the American dream embodies a contradiction within American morality. On the surface, most Americans profess morality, while, at the same time, American consumer dollars fuel the sex industry. It is not a question of whether pornography is right or wrong, but that America legislates against pornography, even while pornography represents the largest financial industry in American entertainment. The collision and collusion of these two ways of structuring America's relation to pornography is mirrored in the collision of worlds both real and imagined within the framing of Sultan's photographs. In one image, an actress waiting for a scene sits in a room with objects belonging to the young daughter who actually lives there. Sultan's work empathetically inquires about the status of workers in the sex industry. Presented in a de-sensationalised fashion, a common humanity is presented in the banal nudity of the actors and actresses. They gaze out of windows, make phone calls and grab a smoke. At the same time as this humanity is revealed,

dehumanisation is hinted at through visual asides commenting on the transformation of women into objects of industry, machinery to be manipulated. In still others, Sultan's lens frames humorous visual conjunctions playing on the erotic.

The very spaces Sultan frames have already been framed. Not only do we see evidence of the constructed nature of the pornographic image, we see a space that is beyond the screen of pornography and, at the same time, ignored in the consumption of pornography, namely the homes the films take place in. Representing one dream of the domestic, the home offers an ambiguous space both in reality and the reality framed by Sultan's photographs. Even when photographing the studio stage sets for adult films, Sultan focuses his static camera lens on what is marginalised in the movement of the moving camera, the backdrops evoking middle-class suburban life. Suburbia is the setting for most American sitcoms, offering another strange blurring of the sites and sights Sultan photographs. The suburban world becomes overdetermined. The site becomes a sight, something visually loaded with multiple layers of desire and fantasy.

Chapter 10

There is no happy medium: Derrida and the televisual

Stan Douglas' *Every Building on 100 West Hastings*, in its depiction of the homogeneity of urban existence, owes something to the early twentieth-century American realist Edward Hopper. The cinematic lighting of Douglas' photograph opens it up to the realm of contemporary cinema, a debt shared by Hopper. Filmmakers, such as David Lynch, in turn cite Hopper's work. Works of photography borrow ideas from cinema – a debt that is repaid through the way cinema can borrow from other media. The cinematic quality of contemporary painting is also closely related to the medium of photography, providing approaches to painting that consider constructing paintings in very different terms from early nineteenth-century culture. German painters such as Neo Rauch, Gerhard Richter, Sigmar Polke and Anselm Kiefer offer potential moments to explore the relation between painting, photography and cinema. The easy interconnections that can be made between photographers, painters, cinema, installation, site-specific art and other new media points to a culture where the role of multi-media has constructed a fluid world resistant to the rigid modernist ideals espoused by figures such as Clement Greenberg or Kant. The permeable borders between media, in contemporary art, reveal a potential for appropriation that Derrida suggested early in his career through the idea of intertextuality.

Against a modernist ideal that art should only be about art, leading to a subjective formalism that deems what is significant and what isn't significant, Derrida's work suggests that not only

do texts remain open to other texts, but images remain open to other images. An image does not just have to refer visually solely to the history and tradition of its medium. Photographs can relate to cinema. Cinema can relate to painting. Painting can refer to photography. And so forth. As Derrida's thought suggests, there is an intertextuality between the various creative media. If Greenberg wanted to hunt the arts back to their natural grounds, their medium, Derrida's work suggests such purity comes only by way of constructing the very terms for purity. For Derrida, works have a potential to be appropriated that leaves them open to new interpretations and being placed in new contexts. One medium can draw upon another, as in the case of photography drawing upon cinema and painting in the work of the photographers considered in the last chapter. In this final chapter, I want to look briefly at the relation of popular visual media to the work of Derrida.

Echographies of Television (*Echographies de la télévision: Entretiens filmés*, Paris: Galilée, 1996 – Jacques Derrida and Bernard Stiegler, *Echographies of Television*, trans. Jennifer Bajorek, Cambridge: Polity, 2002) offers Derrida's most sustained engagement with the mass media. Comprising a lengthy series of interviews with Bernard Stiegler, the two intellectuals discuss the role of the media in contemporary culture, paying particular attention to politics. In the case of television, the role of the media in shaping political events is something apparent in Derrida's thoughts from the early 1990s. The interview form also takes on a prominent role in Derrida's later work. The interview offers an opportunity for Derrida to talk to a larger public audience. In so doing, he presents his thought in a far more accessible manner, as has been suggested in the Introduction. Some of what Derrida discusses, in the case of his interviews with Stiegler, will be unfamiliar to individuals who know little of French politics in the 1980s and early 1990s. At the same time, there are moments where Derrida offers clear ways of seeing how deconstruction adapts to a world defined by contemporary technology.

We live in a world where identity is marked by multiple media structures (what Derrida terms 'the televisual') – intermediaries that construct and constrict an individual's sense of self. Mediated images dominate our visual experience. An image always mediates how we picture the world, making all images, even art, intermediaries of an existence in representation. Derrida, from the start, suggests that *écriture* comes to stand for all forms of representation, something alluded to early on in our consideration of his work. In relation to technology, Derrida recognises a situation where the mediation of human existence by visual representation reveals the limits to any form of representation as an intermediary of experience. In having to present ourselves to others through words and images, we negotiate systems existing beyond our individual control to transform except through the mediation of our words and our works of art. In a visual culture dominated by popular media, popular media play an even greater role in impacting contemporary art.

Derrida indicates, in a world marked by the advent of MySpace, Second Life and Online Gaming, that the virtualisation of our existence is an additional instance of the effects of *écriture*. In another late collection of interviews and public pieces (*Papier machine*, Paris: Galilée, 2001 – *Paper Machine*, trans. Rachel Bowlby, Stanford, CA: Stanford University Press, 2005), Derrida suggests that the blank page is already a virtual medium, presenting conceptually ideas similar to the latest in technology. For artists, the attraction and anxiety that new media cause has to do with the way technology presents new possibilities for potentially expressing oneself visually. In being able to relate to images in new, unimagined ways, the ability for works to be taken out of one context and relayed into another reaches a point of critical mass. The potential of citation, or, as Derrida refers to it, iterability, can lead to the virtual appearance of dead celebrities such as John Wayne in beer commercials or the dream-like experience of a Bill Viola video.

Derrida, in adapting to this new situation, became more accessible through interviews. In 1993 Derrida conducted an interview with Peter Brunette and David Wills in *Deconstruction and the Visual Arts* (Cambridge: Cambridge University Press, 1994), exploring a number of topics concerning the relation of his work to the visual arts. As in other interviews, Derrida offers good examples of how to think about ideas concerning deconstruction. For instance, Derrida cites the modernist classic by Proust, *Remembrance of Things Past* (1912–22). Derrida suggests that we can give an account of all the events leading up to Proust writing his masterpiece. We can also offer any number of analyses of the content of the work. Derrida notes the necessity for all this work, but he also notes that nothing can explain fully the existence of Proust's work. Nothing can fully account for why the work happened. In happening, Derrida links the idea of the work of art to his analysis of the term 'event'. The idea of an event was one of the key components to Derrida's important early essay 'Signature Event Context'. We have already seen how the ideas of context and signature affect works of art. Seeing the work of art as an event makes it something that will continue to grow in terms of meaning, without its meaning ever conclusively being delimited. Derrida cites the example of Van Gogh, in this case as an artist who has been equally analysed to the same extent as Proust. Before a Van Gogh painting, one sees a physical object bearing witness to the artist's absence through the presence of his physical trace, a brushstroke. All the analysis of Van Gogh can do nothing to explain the event of this brushstroke completely. Standing before a Van Gogh, as a viewer, I gaze at the same canvas as Van Gogh, but it is a world of difference that marks my act of gazing from his. In mortality both are marked, however, and vision is marked by mortality, by tears, even if tears in themselves may always be ambiguous. The mythology around Proust and Van Gogh shows how much supplementation a singular work can accrue, and is one of the reasons why

their work provides good cases for understanding the project of deconstruction.

Van Gogh also happens to be one of the artists, if not the artist, who has been represented most frequently in cinema. Besides their important interview with Derrida, Brunette and Wills co-authored a book, *Screen/Play* (Princeton, NJ: Princeton University Press, 1989), focusing on the relation between cinema and deconstruction. They offer interesting ways of translating Derrida's thought into cinematic terms, and their text provides another excellent introduction into the possible relations between Derrida's thought and cinema.

Ever-moving pictures

In literal terms, Derrida appeared twice in cinema, first in *Ghost Dance* (1983). Given a more substantial role in the documentary *Derrida* (2002), the French philosopher is presented through a series of interviews, conferences and daily routines. If remaining somewhat enigmatic, what comes out clearly in this film is the ability of Derrida to articulate himself in relation to questions posed within the interview format.

In terms of cinema, there are any number of directors who could be cited as offering means of exploring ideas surrounding deconstruction. Because of space, let's limit ourselves to just a few: Takashi Miike's *Gozu* (2003), Peter Greenaway's *A Zed and Two Noughts* (1985) and Jean-Luc Godard's *Le Mépris* (1963).

In *Gozu*, Miike takes apart the yakuza genre of Japanese cinema. Miike is noted for the extraordinary number of films he makes a year (as many as six) and the level of violence in many of his cinematic works. The violence in Miike, however, seems to move far beyond simple sensationalism by offering a critique of our own act of viewing violence. Miike opens up a space for self-criticism by both the viewer and the director. While frequently remarking on cinematic artifice, the violence also serves as a backdrop for movies involving individuals who are marginalised in society.

In *Gozu*, the two main characters are represented as being marginal in the world of crime through the eccentricities of their gang's boss. The characters travel to a city, Nagoya, marginal to the major urban centres of Japan. Strange characters populate this nearly abandoned city, enhancing a sense of distance from reality. Here, the two yakuza members encounter Buddhist demons, mysterious women, a cross-dresser, an American and other characters not normally associated with the yakuza genre. In particular, Miike's work addresses the homo-socialisation within the traditional yakuza genre. Men form intimate relations with other men, leading to the displacement of sexual feelings impacting their relations with women. The depiction of women in this genre is marked by extraordinary levels of misogyny. The misogyny of the yakuza genre, however, enhances and reflects back attitudes present in contemporary and historical Japanese culture.

Miike's work in echoing this misogyny apes the genre it is taking apart, while exploring the reasons for this misogyny in the inexpressible love between the two protagonists. As a result, Miike reframes the misogyny both inherent in the genre of yakuza cinema and also within Japanese society at large – something the popularity of the yakuza genre reveals. At the same time, Miike presents women in ways that raise them to the level of deities. For instance, in *Gozu*, the inn owner's wife is the embodiment of an ancient nurturing deity, whose lactating breasts provide the town's chief export. Miike's film suggests, most radically, that the buddy film provides a narrative of sublimated homosexual desire in yakuza society. Miike transforms what at first appears to be a yakuza film into a journey to and through hell and paradise, while also posing a series of irresolvable questions concerning gender and sexuality within cinematic representation. In crossing genres and playing with the conventions ordering the yakuza genre, Miike's work offers visual examples of deconstruction at work.

In *A Zed and Two Noughts*, the British filmmaker Peter Greenaway takes apart a tradition of taxonomy that grew out of

Enlightenment culture. In exploring the absurdity of reason taken to irrational ends, Greenaway presents the story of two brothers whose wives die in a car crash near the institution where they work, a bizarre zoo. The title of the film is inside the work, as neon letters spell out 'Z O O' near the car crash site. Like most of Greenaway's work, he draws upon his background in painting to cite compositions from the work of artists. Greenaway studied to be a painter for several years and regularly exhibits his drawings and other works on paper. (Greenaway was the second guest curator for the *Parti Pris* series Derrida inaugurated with *Memoirs of the Blind*.) The film also visually draws upon the work of late nineteenth-century pioneers in motion photography, such as Eadweard Muybridge (1830–1904).

The two brothers go through a series of ever more elaborate rituals in their process of mourning, taking up a theme we have seen addressed by Derrida. In particular, one of the elements organising this film, as well as others by Greenaway, is the theme of death. In studying death from a scientific gaze, the two brothers apply their knowledge as zoologists to set up experiments allowing them to observe the process of decay. The hypothesis they propose for their studies is to explore the process of life in reverse, from death to birth.

A series of 'coincidences' leads to the accident killing the brothers' wives, but they, as scientists, do not believe in coincidences and seek to find a meaning to the accident, absurdly analysing every little detail – something Derrida does in his textual explorations. Greenaway also continues his allusions to painting through the character of a surgeon named van Meegeren, making direct reference to a famous forger of Jan Vermeer. Van Meegeren presented himself as an art dealer in the 1930s and 1940s. During World War II he sold a work by Vermeer from the Netherlands to Germany, breaking a law concerning the transference of national treasures to a hostile foreign country. Facing such a charge, van Meegeren revealed that he painted the work in question, as well as

a number of other works considered at that time to be by Vermeer. In Greenaway's film, the surgeon van Meegeren surgically alters women to make them appear like the women in Vermeer's paintings, providing one of the other structures organising this film.

In exploring the limits of what the scientific gaze can reveal about death, Greenaway's work explores the structures humans use to order the world they live in, while suggesting how fragile and arbitrary these structures can be. Greenaway's films, in indicating how the way we frame the world determines the meaning we construct, offer a deconstructive cinematic project that continues today, both in cinema and in virtual media, such as the Internet. The advent of virtual communities sharing video and works of creativity has led to a new popular media that cinema must now negotiate.

In the work of Godard, we may see the closest cinematic exemplar of ideas relating to the thought of Derrida. In particular, Godard deconstructs the central cinematic relation between sound and image. If cinema reframes the truth twenty-four frames per second, according to Godard's famous formula, then how Godard structures the relation between sound and image is one of the features marking nearly all his work. In *Le Mépris*, Godard presents a work theatricalising the problem of translation, a topic discussed by Derrida. Godard achieves this through the different languages being spoken simultaneously by the various characters. French, English, German and Italian layer over one another in a work that becomes impossible to translate fully. Godard, in thematising translation, even includes a translator as one of the supporting characters.

In relation to characters, Godard's work operates in a space complicating the limit between cinema and reality. Actors not only play characters, but also play themselves. For instance, Fritz Lang stars as himself, one of the most important directors in German cinematic history. He has been hired by an American producer, played by Jack Palance, who gives an over-the-top performance,

citing affirmations from a miniature book. The producer wants to adapt Homer's *The Odyssey* and hires a French writer to do the adaptation. The French writer's wife, played by Brigitte Bardot, accompanies her husband to Capri, becoming the object of the American producer's attention as the film production faces ever-growing problems.

Through the theme of cinematic adaptation, Godard's film addresses another form of translation, as Homer is translated into a contemporary version and vision. In the footage of the film within the film, we see close-ups of classical statues representing the gods and goddesses of Classical Antiquity who move the events in Homer's epic tale of female fidelity. Interspersed are scenes of nude women swimming, greatly pleasing Palance's character, who was bored by the statues. He wants less philosophy and more skin. If at one level a cheap shot at an American stereotype, Godard's film also alludes to a world of contemporary American cinema through the movie posters filling the backgrounds to his work. In particular, posters for the work of Samuel Fuller can be seen. Fuller was a director admired by Godard and the other French New Wave filmmakers of the 1960s, even as he was stuck making B-feature films in America – the type of film shown as an accompaniment to a major feature as part of a double billing.

Godard's film is shot at one of the most famous sets in the history of cinema, Rome's Cinecittà, enhancing his cinematic self-reflexivity. In the opening credits, Godard's film announces itself as a work of fiction told on the famous set, presenting a scene depicting the filming of a tracking shot that reveals the rails, cart and cameras producing the illusion of movement that is one of the most compelling aspects to cinema. Godard, in these self-reflective gestures, questions his own motivations for making films. Lang presents a philosophical European director through whom Godard explores what it means to make films in the contemporary world. In one scene, Lang and the French writer discuss the work of Friedrich Hölderlin, a poet critical to

Heidegger's exploration of the work of art. In this discussion, the irrelevance of such deep thinking within a world dominated by American spectacle is broached – one of the countless subjects presented in Godard's remarkable film.

Indeed, Godard's *Le Mépris* warrants several volumes devoted to exploring the ways he deconstructs a tradition of cinema, the values traditionally affiliated with the medium and the role of cinema within an ever-changing culture. For example, what does Godard's version of *The Odyssey* have to say about trying to adapt *The Odyssey* today? That his work has so many points of congruence with Derrida's may have to do with the similarities in their formative cultural experiences. Both were products of the rich period of French intellectual and creative thought that was discussed in the Introduction. In reinventing themselves and their approach, Derrida and Godard provide contemporaries whose achievements continue to inspire artists, filmmakers, philosophers and other creative individuals today. In exceeding the limits of analysis, the work of Derrida and Godard offer countless possible areas of exploration. In this volume, I only hope to have provided a few starting points for the reader's exploration of the thought of this dynamic thinker.

Conclusion

The bibliography relating to Derrida is extraordinarily large. On average, Derrida produced a book a year, as well as countless interviews, essays and other texts. The secondary literature on Derrida is even more immense. There are volumes devoted to almost every aspect of Derrida's thought. The visual is no exception, though there are far fewer volumes addressing this issue relative to other topics. In terms of what is available in English, the work of Mark C. Taylor, who has been mentioned previously, provides some important texts dealing with the visual from a position informed by Derrida. Besides *The Picture in Question*, the books *Hiding* (Chicago: University of Chicago Press, 1992), *Disfiguring*, (Chicago: University of Chicago Press, 1997), and *Tears* (New York: SUNY Press, 1990) are recommended. The work of Gregory Ulmer offers some early attempts to apply Derrida's thought to television in *Applied Grammatology* (Baltimore: Johns Hopkins University Press, 1985) and *Teletheory: Grammatology in the Age of Video* (New York: Routledge, 1989). One also could look to some of the texts by David Farell Krell, especially *The Purest of Bastards* (University Park: Pennsylvania State University Press, 2000), a text that offers a very advanced, but important, reading of Derrida's texts on the visual arts.

In approaching the viewing of art from a deconstructive perspective or creating visual art informed by deconstruction, no single rule necessarily orders how to begin. One begins where one finds oneself, as Derrida notes on more than one occasion. Nonetheless, it is important to take into consideration Derrida's

reiterated statement that deconstruction is not a method applied to a work. Rather, Derrida repeatedly suggests that the works he analyses deconstruct themselves. The process of deconstruction is at work already within the work under consideration. Thought of as a form of internal decay, deconstruction is a process of understanding the structures and strictures making any work of art possible. A representation is created through the momentary stabilisation of a set of structures, allowing for an image to be recognised as a work and for it to have an effect on a viewer. In Derrida's texts, his patient acts of reading and his patient readers are offered an opportunity to relate not only to texts, but also to the world we create in, differently.

Derrida's approach bears some resemblance to the Zen *koan*. An irresolvable question or parable (such as 'the sound of one hand clapping'), the *koan* forms a focus for Buddhist acts of meditation. Enlightenment is arrived at through an understanding gleaned by focusing on the *koan*. The *koan* can be thought of in relation to Derrida's discussion of *aporia* (*Aporias*: Stanford, CA: Stanford University Press, 1993). An *aporia* is an impassable passage. In Derrida's thought, the idea of *aporia* is critical to comprehending his focus on ethics and the question of making decisions. As artists, we are regularly presented with difficult decisions, even in basic forms such as how to make a mark on a page and what to show a viewer. For Derrida, a decision ethically made involves the experience of *aporia*, of the impossibility of knowing what decision to make. The ethical decision, in Derrida's work, constitutes moving from unknowing to making a decision, even if the consequences remain unknown. Far from the accusations of relativity his work is often charged with, he shows the necessity and the profound difficulty of making decisions – a difficulty relating to creative decisions as well as ethical decisions. Indeed, for Derrida, every decision is ethical, and all our decisions must necessarily be questioned and challenged.

Derrida never ceased exploring limit cases where a structural opposition broke down, and, in part, these limit cases provide situations where a decision has to be made. Limit cases reveal problems within a structure built simply through oppositional thought. In focusing on ideas and phenomena following a logic of 'both/and', instead of 'either/or', Derrida offers a mode of thinking that seems to adapt well to a world where the multiple structures ordering our works of art and our daily lives collide. The collision of all these structures in individuals living within the twenty-first century supplies ample moments where the fragments of our identity fall apart, like the shattered windows and canvases within Magritte's paintings. Our human condition is always marked by mediation, as Derrida's thought repeatedly shows.

In being an intermediary for your reception of Derrida, I have tried to suggest only a few of the countless ways his works can be associated with examples from contemporary visual culture. A series of decisions have been made in crafting this text, necessitating going through the experience of *aporia*, of passing through what seemed impassable passages. Nonetheless, in trying to think through these decisions, it has been my hope to begin a process the reader will continue from here in negotiating and reframing the texts and ideas of Jacques Derrida.

Notes

1 The intimacy of the materiality of sound to writing endures beyond the phonograph in computer drives writing music and film on CDs and DVDs.

2 As parodied in *The Simpsons* on numerous occasions through non-existent sequels emblazoned on the cinema's marquee. As part of a series, this book also operates as a supplement, as does any text on Derrida. Moreover, there can always be future additions and editions to this series. Also, this endnote operates as a supplement to the main text. There is no end to supplementation.

3 One can cite the countless appropriations of Manet's *Olympia* and da Vinci's *Mona Lisa*, as only two of the most well known (and already cited) works to be appropriated. Of course, Manet was appropriating Titian's *Venus of Urbino* (1538), while some would suggest that da Vinci was appropriating the sitter of the Mona Lisa for a displaced self-portrait.

Selected bibliography

Bennington, Geoffrey and Jacques Derrida, *Jacques Derrida*, trans. Geoffrey Bennington, Chicago: University of Chicago Press, 1993.

Brunette, Peter and David Wills, *Screen/Play: Derrida and film theory*, Princeton, NJ: Princeton University Press, 1989.

_____, eds *Deconstruction and the Visual Arts: Arts, media, architecture*, Cambridge: Cambridge University Press, 1994.

Carroll, David, *Paraesthetics, Foucault, Lyotard, Derrida*, New York: Routledge, 1987.

Derrida, Jacques, *Writing and Difference*, trans. Alan Bass, Chicago: University of Chicago Press, 1978.

_____, *Speech and Phenomena*, trans. David B. Allison, Evanston, IL: Northwestern University Press, 1973.

_____, *Of Grammatology*, trans. Gayatri Chakravorty Spivak, Baltimore: Johns Hopkins University Press, 1974.

_____, *The Post Card: From Socrates to Freud and beyond*, trans. Alan Bass, Chicago: University of Chicago Press, 1987.

_____, *Positions*, trans. Alan Bass, Chicago: University of Chicago Press, 1981.

_____, *Dissemination*, trans. Barbara Johnson, Chicago: University of Chicago Press, 1982.

_____, *The Truth in Painting*, trans. Geoff Bennington and Ian McLeod, Chicago: University of Chicago Press, 1987.

_____, *Memoirs of the Blind: The self-portrait and other ruins*, trans. Pascale-Anne Brault and Michael Naas, Chicago: University of Chicago Press, 1993.

_____, *Right of Inspection*, trans. David Wills, New York: Monacelli Press, 1998.

Derrida, Jacques and Peter Eisenman, *Choral Works*, ed. Jeffrey Kipnis and Thomas Leeser, New York: Monacelli Press, 1997.

Derrida, Jacques and Paule Thevenin, *The Secret Art of Antonin Artaud*, trans. Mary Ann Caws, Cambridge, MA: MIT Press, 1998.

Krell, David Farrell, *The Purest of Bastards: Works of mourning, art, and affirmation in the thought of Jacques Derrida*, University Park: Pennsylvania State University Press, 2000.

Papadakis, Andreas, Catherine Cooke and Andrew Benjamin, eds. *Deconstruction*, New York: Rizzoli, 1989.

Taylor, Mark C., *The Picture in Question*, Chicago: University of Chicago Press, 1999.

Wigley, Mark, *The Architecture of Deconstruction: Derrida's haunt*, Cambridge, MA: MIT Press, 1993.

Glossary

Deconstruction – An intellectual movement that may be traced back to Jacques Derrida's texts. Derrida uses the word as a means of discussing his project as a writer. Derrida 'deconstructs' literary and philosophical texts, as well as writings on art, by revealing the biases within the foundations of a text's structure. Anchored by binary oppositions, texts create structures of meaning where one term is favoured in opposition to the other. Derrida exposes the biases within these oppositions and, at times, reverses them to explore the effects that such reversals may have on a text. He also finds concepts within the texts he reads that resist the oppositional logic of 'either/or' that structure the work. The oppositions within the work begin to falter, and Derrida uses these points of instability to deconstruct the text he is reading.

Différance – A conflation of the French words for 'deferring' and 'difference', Derrida introduced the concept of *différance* in the late 1960s. The term, a misspelling of the French word for difference, emphasises two key elements to Derrida's thought: 'difference' and 'delay' (deferment). All forms of signification, or what we commonly call 'meaning', are subject to effects of difference and delay. For instance, when initially viewing a work by Pablo Picasso, the forms may be challenging to interpret. With repeated viewings, however, a Picasso, or any work, begins to appear differently. New forms become apparent. Meaning accrues over time. The meaning of a work in the present may be both greater and/or lesser than what it was in the past. Our understanding of art and individual works of art is subject to changing over the course of time. Likewise, our growth in understanding reveals how the meanings of some works of art become apparent only over time or after a delay.

Écriture – 'Writing' in French, Derrida expands the term to include potentially any form of mark making. Derrida uses the term 'arche-écriture' to suggest that underlying any act of communication is an act of interpreting marks, such as sounds or visual signs. Derrida stresses how acts of interpretation on the part of a person receiving or reading a message or text (even a text message) can delimit the potential ways of interpreting the message in question. Derrida reveals instances where the process of interpreting messages or signs breaks down within a text. At these points, a text reveals an ambiguity that unsettles the stability of any attempt to totally understand the work or text.

Logocentrism – A term Derrida uses to represent a tradition of Western thought that his work deconstructs. Taking its name from the Greek word for 'word' (*logos*), Derrida defines logocentrism in relation to his excavation of attitudes about writing within Western and non-Western cultures. Derrida suggests, convincingly, that within the Western tradition writing is viewed in largely negative terms, as something secondary and less authentic than the phenomenon of speech. Speech is tied to an identifiable author who is fully present before an audience. Derrida suggests that the privileging of speech covers over the fault lines inscribed in the ideals of Western thought.

Metaphysics – A tradition of Western thought that Derrida's work challenges. Some of the thinkers associated with this tradition are analysed by Derrida, such as Kant, Hegel, Nietzsche, Husserl and Heidegger. Western metaphysics is intimately bound to the tradition of thought that Derrida terms 'logocentrism'. The values of presence, totality, singularity, universality, Self and centrality are privileged within these traditions of thought. Derrida takes apart these foundational values, revealing how absence resides within presence, fragmentation within totality, repetition within singularity, difference within universality, Other within Self, and at the centre eccentricity. In unsettling these traditions, Derrida's readings of texts show how the values of Western thought deconstruct themselves.

Parergon – A term from Kant's *Third Critique* that Derrida appropriates in *The Truth in Painting*. A *parergon* is not considered part of the work, or *ergon*. A *parergon* is beyond the *ergon* or work and, at the same time, it is something that is bound to the work. Kant cites three examples that Derrida explores in his essay: columns on a building, clothes on a statue, the frame of a painting. The frame occupies the greatest amount of Derrida's attention. Derrida shows the frame to be more than simply a border to a painting. He expands the notion of the frame to consider how historical context, institutions, individual viewers, cultural ideals and other phenomena beyond the work come to frame the work of art, revealing how the frame provides only a potentially permeable border to the work.

Post-structuralism – A tradition of thought emerging from the mid-1960s that often includes Derrida and several of his French compatriots, such as Jean-François Lyotard, Jean Baudrillard, Gilles Deleuze, Paul Virilio and Paul de Man. The thinkers associated with post-structuralism offer a critique of structuralism. At the same time, there are great differences between these individual thinkers. Additionally, some, such as Lyotard and Baudrillard, are also intimately associated with postmodernism. Derrida, while typically rejecting both the labels of post-structuralism and postmodernism, is noted for his early texts, which offer close readings of some of the important proponents of structuralism, such as Claude Lévi-Strauss, Michel Foucault, Jacques Lacan, Roland Barthes and others. Some of these thinkers are noted for having a structuralist phase and a post-structuralist phase, such as Barthes, Lacan and Foucault.

Structuralism – A tradition of thought that emerged in continental Europe during the mid-1950s. Thinkers approaching a subject from a structuralist perspective try to understand the ordering oppositions of the subject they are analysing. Derrida critiques the reliance on binary oppositions by structuralist thinkers, perceiving a repetition of the hierarchical structures ordering the Western tradition that structuralists often thought they were critiquing. See 'Post-structuralism'. The work of the Swiss linguist Ferdinand de Saussure was integral to the development of structuralist theory.

Supplement – A supplement is something added to a work. Not considered part of the original work, a supplement nonetheless adds to the original, transforming the work in the process. A supplement can be placed anywhere within a work, such as the pages of definitions you are reading at present. Derrida expands the term 'supplement' to consider how key ideas within the traditions of Western metaphysics and logocentrism depend upon relations of supplementation. The Self requires an Other, wholeness is defined only in relation to fragmentation, singularity arises only through repetition and addition, and at the origin there is division. Derrida explores the supplement in his early texts, especially in *Of Grammatology*.

Trait – French word for 'trace' or 'trait'. As with writing, Derrida expands the term *trait* to include an array of figures, both graphic and visual. The term arises frequently in Derrida's considerations of art. On different occasions, *trait* becomes a term marking the absence of the artist, while also being that which gives an artist her or his identity. Identity is attached to a material trace, creating an illusion of presence that Derrida's texts deconstruct.

Index